Publishing
Phot⚬graphy

Publishing
Photography

Marketing Images,
Making Money

Richard Weisgrau

ALLWORTH PRESS
NEW YORK

asmp
AMERICAN SOCIETY OF
MEDIA PHOTOGRAPHERS

10 09 08 07 06 5 4 3 2 1

Published by Allworth Press
An imprint of Allworth Communications, Inc.
10 East 23rd Street, New York, NY 10010

Cover design by Derek Bacchus
Interior design by Joan O'Connor
Page composition/typography by Integra Software Services, Pvt. Ltd., Pondicherry, India

ISBN-13: 978-158115-457-3
ISBN-10: 1-58115-457-7

Library of Congress Cataloging-in-Publication Data:

Weisgrau, Richard.
 Publishing photography: marketing images, making money/Richard Weisgrau.
 p. cm.
 Includes index.
 ISBN-13: 978-1-58115-457-3 (pbk.)
 ISBN-10: 1-58115-457-7 (pbk.)
1. Commercial photography. 2. Photographs—Publishing.
3. Photography—Business methods. I. American Society of Media Photographers. II. Title.

 TR690.W444 2006
 770.68'8—dc22
 2006016955

Printed in Canada

Contents

Introduction

Publication can be a source of additional income for all photographers, whether amateur or professional. Consequently, many photographers aspire to have their photographs published at some time in some media. The professional publication photographer must make that aspiration the central goal of his business because his monetary income depends on it. The amateur photographer does not depend on a revenue stream from publication, but he too can earn money from publication. Amateurs and professionals alike can get psychic income—meaning the good feeling of a job well done—from seeing their photographs published. Seeing your photographs used by others in print or electronic media can make you feel good about yourself as a photographer. It tells you that someone else values your photography.

The opportunities to publish photographs are growing every day. Digital technology has created new and exciting electronic media applications that require photographs. Digital technology has also made producing

printed publication simpler by making it easier to create printed materials and to use photographs in them.

Magazines, newspapers, newsletters, mailers, circulars, catalogs, brochures, calendars, posters, greeting cards, and other items now exist in both print and electronic formats. The different formats all have one thing in common: they make use of photographs.

Strangely, for a long time there has been some mystique connected to publishing photography. Many photographers believe that there is some special ingredient required to get a photograph published. That is a mistaken notion. There is only one requirement for getting a photograph published: It has to meet the needs of a person, company, or institution that publishes photographs. Meeting that need on a regular basis is not a matter of chance. It is a matter of studying the publication markets, planning an approach to offering photographs to those markets, and then implementing your plan.

Publication photography is a business. To be successful at it requires that you have a range of knowledge in addition to photographic talent and skills. Most of those business skills are covered in this book, but topics like business planning, copyright, and negotiating are not covered in their entirety. Like most business topics, the latter topics could be and are the subject of entire books, so we only present the basics here.

This book focuses on helping you understand the breadth and depth of the different market segments and the applications therein within the full spectrum of the publication photography marketplace. The concentration of information is aimed at helping you identify who publishes the kind of photographs you want to take and how you can sell your work to them.

This book is written to help you find ways to publish your photography, make money, and enjoy doing it.

Chapter 1

Publishing
Opportunities

Photographers have numerous outlets in which to publish their photography. Each year, these outlets spend billions of dollars to license the use of photographs for publication in a variety of media applications and for a variety of purposes. The publishers of photography are as vast as the landscape of society. Individuals, businesses, institutions, associations, sports teams, publishers, advertising agencies, public relations firms, government agencies, military services, greeting card companies, poster publishers, and calendar publishers are just a sampling of the outlets that need photographs for publication. Even better is the fact that they will pay for the use of the photographs in their publications.

Just think about newspapers alone. There are daily, weekly, biweekly, and monthly newspapers. Newspapers serve a wide variety of readers. Some are dedicated to sports or a particular sport. Some cover general interests. These newspapers can be international, national, regional, or local. "Local" can be a city or a village. While no one can produce an accurate count of the total number of newspapers that

exist, it certainly has to be in the tens of thousands world-wide. As with newspapers, the volume of other published media applications is mind-boggling.

As a consultant, I had access to a study done by a major marketing research company that was commissioned by a major corporation to analyze the publication photography marketplace. That study identified 3,670,000 entities that purchased photography. A market that huge is full of opportunities to publish your photography. But to successfully seize some of these opportunities, you have to know how to select which ones to pursue and how to pursue them.

THE QUALIFIED PUBLICATION PHOTOGRAPHER

First of all, don't let the word "qualified" take on more meaning than it has. There are few qualifications for being photographer who makes publishable photographs. You have to make technically acceptable photographs. For 90 percent of the photographs you will take, a camera with automatic focus and automatic exposure will provide technically adequate photographs. The more challenging qualification is that you must make well-composed, aesthetically pleasing photographs. That requires some talent. Some are born with it. Others develop it by practice. Some never achieve it. The more talent you have, the more likely you are to be published regularly.

There is one circumstance when technical expertise and aesthetic talent don't matter as much. That is when news is being made. If you come upon a newsworthy situation and your photographs are either the only ones available or among only a few that are available, the publisher is in a situation where it has to go with what it can get rather than what it wishes it had. Of course, these

situations are few and far between. Finding yourself in such a situation is a matter of luck, not preparation.

SELF-EVALUATION

Self-evaluation is the other qualification for success in publishing your photographs. You have to appreciate what you photograph best, know who publishes that kind of work, and understand how to approach those parties to sell them on using your photographs.

Determining what kind of photography you do best depends on your natural inclinations and life experiences. Evaluating what you are inclined to do best is actually an enjoyable process. If you have not had the experience of doing many different types of photography, one way to make such an assessment is to peruse Web sites and page through magazines, books, and annual reports, making note of the specific images that you wish you had taken. Do this repeatedly over a period of time. Evaluate the consistency of your findings. You will most likely see a pattern emerge. Perhaps you have often centered on still life, or action and sports, or large-scale production advertising images. Perhaps candid documentary images appeal to you more than images of staged products or posed models. In that process, you are making a judgment about your art. Your artistic inclinations have a relationship to your passion for what you will photograph. It is always easy to be passionate about what you love to do. Passion for what you are doing will contribute greatly to your success at being published.

Solicit Feedback

You can enlist the assistance of others. Photographers are known for admiring their own work and other photographers'

photographs for all sorts of reasons. After all, it was the thrill of making photographs that started all photographers on their way in photography. Soliciting the opinions of fellow photographers about the quality of your photography is a good place to start when evaluating you level of expertise. Beware, though: some photographers are notoriously honest about such things, and the truth might hurt. But you are better with the painful truth than misleading flattery. Needless to say, you have to be concerned about insincere praise because a photographer doesn't want to hurt your feelings. Just be as careful as possible in appointing critics to review your work. "Honest" and "diplomatic" are the words that come to mind when I think of selection criteria for a critic.

Unlike fellow photographers, photography buyers are in the business of making critical selections of photographs. They spend their days choosing the images that best fulfill their own criteria for publication, including a photograph's aesthetic impact. Feedback from photography buyers like photo editors, art directors, and communications directors is very valuable in any evaluation of your qualifications. But don't sandbag yourself. Photography buyers are specialized to some degree. They may be buying sports, still life, wildlife, or any one of a hundred or more special types of subject matter. If you are inclined to be shooting sports, don't show your sports photographs to a still-life photography buyer. Find a buyer that routinely evaluates sports photography. That buyer is in your target market, and that is where the standard you have to meet or surpass is set.

Use the Internet

The World Wide Web is a quick and easy way to present your photographs to reviewers. You can create a simple Web site at little expense just for the purpose of having photographs

reviewed. Be sure to comparison shop to assure that you are getting the maximum space you can for the dollars you spend. Photography hosting sites that allow you to upload photographs easily into preformatted layouts is the best way. PBase (*www.pbase.com*) and .mac (*www.apple.com/dotmac*) are both easy-to-use methods of setting up a review site.

Once you set up your review site, you are ready to populate it with some photographs for review. Select twenty of your best photographs in a particular genre of work and load them into your Web site. Then get the e-mail addresses of the reviewers you want to contact. A bit further on, you will learn how to get the e-mail addresses you need. Then, send the prospective reviewer a brief e-mail with a link to the Web page with your twenty images on it. Here's a sample e-mail.

Dear Ed Editor,

I need your help. I am trying to evaluate my ability to meet the needs of a publication like yours. I am new to this kind of photography. I need to know whether I make the grade to be published. I have posted twenty photographs at *www.123itsme.com*. Will you please click on the link and take a quick look at them? Then, if you would send a one- or two-word reply such as "good enough" or "below par," you will be doing me a great favor and saving yourself from getting future unwanted submissions from me.

Thank you,

Pat Photographer

The e-mail has one hundred words in it. It can be read in twenty seconds. The reader can be at your Web site via the link in a few more seconds. It will only take about a

minute for the editor to give your photographs a quick review. He can reply in less than a minute. Altogether, the editor has to spend less than five minutes to help you. Most people can spare five minutes to help another person. That is why you ask for help in the first sentence of the e-mail.

Crosscheck Your Finding

After you complete the previous exercises, be sure to compare the results of your self-evaluation and the feedback you solicited. If you rejected every still-life photo you came across and reviewers tell you that you are a "natural" at still-life photography, you have an inconsistency that needs to be examined. You need to reconcile the difference, or you are likely to end up in the wrong specialty and/or making images that you take no pride in. Unfortunately, many photographers have gone down that path to self-destruction because of a lack of self-awareness. If your photography is going to be great, it has to express you. It can't do that if you don't know who you are and what you do best.

PERSONAL ASSETS

Examine your range of interests, your education, experience, location, material, and financial assets. Identify any unique advantages that you might have. You can also reflect on these to uncover any disadvantages. Here are some examples of the kind of analysis that you might do.

Did you have an area of study or a special interest that lends itself to photography? For example, if you are a photographer who has studied the history of architecture and perhaps once gave consideration to a career as an architect, you would seem to be well suited for architectural and interior photography. You have an advantage. But you are at a disadvantage

if you live in central Wyoming, because the volume of work available is not going to support an architectural photography business. Likewise, if you are a knowledgeable sports enthusiast and understand the ways certain sports are played, you have an advantage in sports photography. But again, if you are living in central Wyoming, you won't find enough assignment opportunities to keep your business running. You need to be in a locale where professional, semiprofessional, college, and even high school sports are being played all year round. This does not mean you should avoid a place like Wyoming. In fact, if you live in Wyoming, subjects like animal farming, outdoor recreation, landscape, and travel might offer opportunities, if you have the accompanying expertise. Likewise, if you live in an oil drilling and/or refining area, you might find it advantageous to be a corporate-industrial photographer, if you have the insights to understand what goes on in those types of operations.

If you studied medicine or medical technology, maybe a medical-scientific specialty is for you. If you love to cook and make aesthetic presentations of your food, maybe food photography is for you. I know a photographer who thought she wanted to be a fashion designer because she loved clothes and the way they expressed the individual. After deeper examination, she became a fashion photographer, because she realized that she had no real talent for *designing* the clothes, but that she had a real talent for *appreciating* the designs of clothes.

Maybe you love children and enjoy getting down to floor level to play with them. You are a natural for child photography. If you can fly an airplane, the field of aerial photography might be for you. If you loved your course or experience in zoology, maybe wildlife photography is for you.

Identify your nonphotographic interests, knowledge, and experiences. Then focus on them as possible subjects and specialties presenting opportunities to exploit more than just your photographic skills alone.

LOCATION IS IMPORTANT

In addition to your interests, knowledge, and experiences, your micro and macro location should be considered. Property you own or have access to might allow lower-cost studio space. Your location might be subject- or specialty-oriented toward a particular kind of photography like surf or ski country, wildlife, or urban locales. You might live in the heart of a specific type of industrial or agricultural region. Almost every tangible item in the universe ends up being photographed for ads, corporate, or editorial use. The simple fact is that your location has everything to do with the kind of photographic opportunities available to you.

Don't make the mistake of thinking you will be paid to travel to distant locations to make photographs. Yes, it happens, but not as often as you might imagine. Travel is expensive, and businesses that publish photographs are not inclined to pay for travel when they can find a photographer in the locale where they need the photographs taken. And that is why your locale is important. What subjects in your locale are likely to become the subjects of published photographs? These subjects are a clue to which market you can access easily.

UNEXPECTED OPPORTUNITIES

Most likely, you will know a situation similar to this one: Years ago, a couple of home- grown terrorists built and exploded a huge bomb at a federal building in Oklahoma. The devastation was horrible. Within minutes of the explosion, professional photographers began to arrive on the scene to capture it for the news media. *Newsweek* used a photograph of a fireman holding a small child that had

been pulled from the rubble. That photograph was published worldwide on *Newsweek*'s cover. What separates that photograph from the many others taken on that day and published is the fact that it was taken by the employee of a utility company who had been sent to the area to read meters. He happened to have a camera with him, and he took the opportunity to make an outstanding photograph that symbolized rescue and survival.

That photograph happened to be well composed and technically suitable. That contributed to its selection as the cover photograph. But that is only a small part of taking advantage of the opportunity. More important was the fact that the meter reader had a camera with him in the right place at the right time. Have you ever missed a great photo opportunity because you did not have a camera with you? I have.

One day I was taking a stroll in my neighborhood. I came across a moving van that had been fully loaded. The amazing sight was a yellow Volkswagen Beetle that had been loaded into the back of the van with all types of parcels stacked around it and on top of it, all the way up to the van's roof. It was a slice-of-life photograph that probably will only be seen once in a lifetime. It was novel enough that it could have been licensed to Volkswagen ("Our Beetle is easy to move") or the van company ("We move it no matter what it is"). I could easily have come up with another five scenarios for making sales of the photograph. But that would have been in vain, because I missed the opportunity to photograph the scene. I didn't have a camera with me. I rushed back to my house and then back to the site, only to see the van slowly turning the corner at the end of the block. The moral of the story is that you cannot make the best of a photographic opportunity unless you have camera with you.

OPPORTUNITY IS UNPREDICTABLE

The Devon Horse Show has drawn show-horse owners from all across the United States to Devon, Pennsylvania, for decades. It is one of the premier horse shows. I live near Devon, but I had never photographed the Devon Horse Show. I wanted to photograph it to test my skill and talent for that kind of photography. I managed to get press credentials that would allow me to roam freely about the event with a camera.

While walking from one show site to another, I passed a teenage girl sitting on a fence and looking at her horse. The scene was not related to the type of photographs I was trying to get that day, but I stopped for a moment and shot one frame of the scene. Figure 1 is a black-and-white reproduction of the original color photograph.

After editing the photographs I had taken at the show, I sent them to the photo editor of a magazine for horse owners so he could consider them for publication. The editor selected a few to illustrate their story about the show. A few weeks later, that photo editor called me to ask if the photograph of the teenage girl with the horse could be used on the cover of the premiere issue of a new magazine that was to be marketed to teenage horse lovers. Of course I agreed and licensed the image for that use. Later, the cover was used to promote the magazine's launch by direct mail and magazine advertising. Since my photograph was the central part of the cover, I was paid additionally for the promotional uses. The promotional uses paid more than twenty times the fee for the cover use.

Of course, I had to get a model release from the girl's parents for it to be used in the promotional applications. Fortunately, the horse show community is a tight one, and I was able to identify the girl, find her parents, and get a model release.

The moral of this story is that you never know what photograph is going create an opportunity for you. You

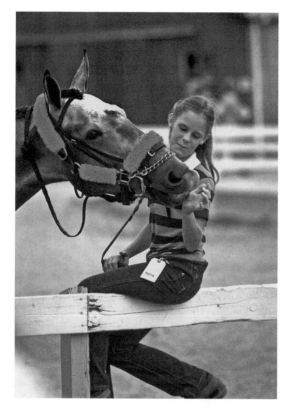

Figure 1

should treat each photograph you take as a potential winner and get the identity of the person in it, in addition to a release. If I had not been able to get the release, the image would not have been used on the cover because the cover was to be used to advertise the magazine. I got lucky, and I was able to capitalize on an unexpected opportunity. If I had not been lucky, I would have missed the opportunity.

THE REWARDS OF PUBLICATION

Being published enriches the photographer in several ways. The most obvious reward is monetary. There are other rewards too. Prestige and personal satisfaction are

psychic income. When you get monetary and psychic income from publication, you are in a great place as a photographer.

Getting Paid

Getting paid for the use of your published photographs is what professional photography is all about. Amateur photographers can get paid too, and they ought to be paid when their photographs are published. After all, the value is in the photograph, not in the business status of the photographer. There is no conceivable reason that an amateur should not be paid for publication in any application that would pay a professional for publication.

There is no doubt about one thing: Photography, whether professional or amateur, is an expensive pursuit. Consequently, getting paid for it is a necessity for the professional, and it eases the burden for the amateur.

Getting paid is one thing. Getting paid the appropriate amount is another thing. No one likes to be taken advantage of. We all want to get a fair price for what we buy and what we sell. The problem is that what is fair is subject to different opinions. The usual way to reach an agreement over what is fair is through the process of negotiation. But to negotiate, you have to have a starting point. You want that starting point to be realistic in terms of average pricing for the kind and level of photography you are doing. You can't simply pull a figure out of the air. You have to know how to price the use of photography. The method of pricing photography usage varies depending on what segment of the market the published use fits into. Subsequent chapters in this book will explore the different segments of the publication marketplace and pricing within those segments.

Psychic Income

You want to feel good about yourself. At least, I hope that is true. I know it is true for me. Publishing your photography can add to your good feelings about yourself in several ways. Here are a few of those ways.

Prestige comes from being recognized by your peers and/or the public for doing something others did not or could not do. When your photograph ends up on the cover of a magazine, other photographers see it as an accomplishment. Remember, a monthly magazine has only twelve covers a year. Those cover photographs are selected from hundreds to thousands of photographs that come across the photo editors' desks each year. Being the photographer of one of the twelve covers of a monthly magazine distinguishes you. Presenting the cover of a magazine in your portfolio impresses the photo buyer, who knows it isn't easy or likely for a photographer to get the cover. That adds to your prestige.

Prestige also comes from having your photographs published in national advertising campaigns and annual reports. Those applications call for top-notch photography, and that means top-notch photographers. Having prestige adds to your self-confidence. It makes you feel good about yourself.

Recognition also contributes to psychic income. If your photograph makes a difference in some worthwhile cause, you will get recognition for it. A stellar example comes to mind.

Years ago, Eugene Smith, a famous photojournalist, spent years photographing the horrible effects on industrial mercury poisoning on the Japanese village of Minamata. He was attacked by goons who were hired by the polluters. He persisted, and his photographs were first published by *Life* magazine, then by many other magazines. Yes, he got paid money for those uses. But he also received international

acclaim when the worldwide public reaction to his photographs embarrassed the Japanese government and the industry, forcing a cleanup and better enforcement of antipollution laws. His photographs made a huge difference in the lives of people. He died shortly thereafter, but he died knowing that his work had helped people who otherwise had no recourse. That's a nice way to go.

Maybe you won't reach the same heights that Eugene Smith did. But if your photography helps a local or national charity, a little league association, your church, or your school be better off, you can be proud of it. The contribution your published photographs make to help good causes is the source of recognition, and recognition feels good.

OPPORTUNITY KNOCKS

Seizing an opportunity and capitalizing on it is the essential element of success. You have the opportunity to do some self-evaluation of your photography likes and dislikes. You have to opportunity to get the opinions of others about how you rank as a photographer. You have the opportunity to make money through the publication of your photography. You have the opportunity to get prestige and recognition from the publication of your photography. Opportunity knocks. Are you going to open the door and let it in.

Chapter 2

Market
Overview

The publication photography marketplace is a vast complex of diverse markets, each with its own needs and requirements. The marketplace is broken down into three segments: advertising, corporate, and editorial photography. While those segments represent the largest part of the marketplace, there has been another, smaller segment developing in recent years. I call that newest segment the *merchandise* segment.

The *advertising market* consists of enterprises that use photographs as part of the process of calling attention to products, services, events, etc., for the purposes promoting their purchase by the public. The *corporate market* consists of companies that publish photography to inform the public about themselves, their facilities, and the nature of their trade for the purpose of promoting the company rather than specific products, services, events, etc. The *editorial market* consists of entities that publish information that is intended to be of value to the public, that is,

information that the public has a need or right to know, and which is not intended to sell or promote a service, a product, or a company. The *merchandise market* consists of entities that use photographs as part of a product rather than to promote it to or to inform the public about it.

It is obvious that there are significant differences among the market segments. In spite of this, the segments are often confused. For example, a corporation might have an internal advertising department, but that department is in the advertising segment and not in the corporate segment. An advertising agency might design a corporation's annual report. But for that specific job, the advertising agency is in the corporate segment and not in the advertising segment, because it is promoting a corporation, not a product.

A magazine might produce an *advertorial*, that is, an advertisement that looks and reads like an article in the magazine. For that specific article, that magazine is in the advertising segment and not in the editorial segment.

It certainly can get confusing, but it is important to recognize the differences because the segment determines the pricing level. Work for the advertising segment generally pays the best, followed by the corporate segment, and then the editorial segment. The merchandise segment is last.

When you classify the use of photographs, you do it based on the purpose the application containing the photograph will be put to, not based on the nature of the entity that is doing the work. When you classify markets, you do it based on the ways those markets will use each photograph.

THE ADVERTISING SEGMENT

Above, I described the advertising market as enterprises that use photographs as part of the process of calling attention to products, services, events, etc., for the purposes of promoting

their purchase by the public. There are many companies that engage in those activities. Here are the most common types: advertising agencies, public relations firms, publicity agents, design firms, and the communications firm, which tends to be all the previous types wrapped into one entity.

Some of the more common advertising applications are listed below.

- Advertorials
- Billboards
- Brochures
- Catalogs
- Circulars
- Direct Mail
- Magazine Display Ads
- Newspaper Display Ads
- Online Ads
- Package Design
- Point of Purchase
- Transit Posters

The above applications have one thing in common: They are trying to get someone to buy something, use some service, travel somewhere, or otherwise spend money somehow. A short test for determining whether an application is advertising or not is figuring out whether it is trying to get someone to spend money.

Advertising can be divided into two main categories: *consumer* and *trade*. *Consumer advertising* is directed at individuals like you and me. It is trying to get us to buy something for personal use. *Trade advertising* is directed at businesses, that is, at people who are responsible for buying for a business. It is trying to get them to buy something for commercial use. There is a very visible line that divides the two categories. That's good, because consumer

advertising usually pays higher fees for the use of photographs than trade advertising does. The rationale for that difference is that the consumer advertising has a wider audience of readers, and the fees to advertise in consumer media are generally higher than those to advertise in trade media.

THE CORPORATE SEGMENT

Corporate America is a large-scale consumer of photography for publication. Corporations use photos to inform the public about the their facilities and the nature of their businesses. Unlike advertising photographs, which are used to sell services or products, the purpose of corporate photography is to promote a company itself. In other words, it is used to sell the company to the consumers and prospective consumers of its products.

The difference described in the previous paragraph is illustrated in this example. We have all seen advertisements that use photographs and that are aimed at selling Chevrolet, Cadillac, Buick, Hummer, and Saturn automobiles. All of those makes are owned by General Motors. All photographs used in those advertisements fit neatly into the advertising segment of the publication photography business because they are examples of General Motors trying to sell cars. General Motors also publishes an annual report that contains photographs. It is sent to stockholders and prospective stockholders. Its objective is to sell the people on the investment worthiness of GM. An example of the difference between corporate and advertising use of photographs is Web sites. Those of the automobile companies that are owned by GM are advertising sites used to promote the sale of specific brands of GM cars. But the general GM corporate Web site is aimed at convincing people that GM is one of the best corporations in the world.

The dividing line between advertising and corporate photography is a thin one. Both are selling something in their own way. The difference is what is being sold: a product or service, or a corporate image.

The word "corporate" is not meant to be as exclusive as it sounds. It actually includes all types of businesses and institutions, incorporated or otherwise. Sole proprietorships, partnerships, not-for-profit organizations like hospitals and charities, and corporations, from those as small as an incorporated photography business to those as large as a multinational company, all fit within the corporate segment of the market. It is the biggest of all market segments. Just imagine how many businesses there are—millions.

Some of the specific corporate applications that use photography on a regular basis are annual reports, calendars, employee newsletters, company magazines, not-for-profit newsletters, facility brochures, business Web sites, audiovisuals, and posters.

THE EDITORIAL SEGMENT

The editorial market consists of entities that publish information that is intended to be of value to the public, that is, information that the public has a need or right to know and which is not intended to sell or promote a service, product, company. You might say that if the application does not fit into either advertising or corporate markets and is not to be used on merchandise, it is an editorial application.

The following list provides examples of the many editorial applications that compose this segment of the market.

- Atlases
- Trade Books

- Consumer Books
- Picture Books
- Encyclopedias
- Text Books
- Trade Magazines
- Consumer Magazines
- Corporate Magazines
- Multimedia Programs
- Informational Web Sites
- Academic Papers
- Newspapers
- Newsletters
- Documentaries
- News Programming

When you peruse the above list, I suspect you will be inclined to challenge the inclusion of corporate magazines in it, because I have previously listed them as part of the corporate segment of the marketplace. The reason corporate magazines are also in the editorial segment list is simple. Many corporate magazines publish stories and photographs that are of general interest and that do not in themselves promote the company that publishes the magazine. Remember, if the photograph is not being used to sell or promote, it is either an editorial or a merchandise-related application.

Another thing that distinguished the editorial marketplace from all others is the fact that the use of a photograph in an editorial application does not require a model release, that is, permission granted by the person(s) in the photograph to publish the photograph. Model releases are required to use a person's likeness for advertising and trade (business) purposes. They are also required to use a person's likeness in a product application, such as on a T-shirt, in a picture frame, or on any tangible that is sold as merchandise. The reason that model releases are not needed for editorial uses

is because the law has taken into consideration that the distribution of noncommercial information to the public ought not be inhibited because someone does not want his picture to be published.

THE MERCHANDISE SEGMENT

The merchandise market consists of entities that use photographs as part of a product for sale. Greeting cards, calendars, picture frames, and posters are examples of merchandise that use photographs.

The merchandise market is one that is growing for photographers. Years ago, greeting cards rarely used photographs. Today, entire greeting-card lines exist that only use photographs. Inspirational posters are another good example. These posters might project a religious message or a motivational message. Picture frames are a perfect example. Many frame manufacturers now include a printed image in the frame to demonstrate how a photograph will look in the frame. Other frames include a higher quality printed image in case you want to buy the combination to serve as a piece of display art. In both cases, the reproduced photograph has been published as an integral part of the merchandise for sale. In all three other market segment applications, the photograph is published as a part of a message.

A DIFFERENT WAY TO SEE
THE MARKETPLACE

There is another way to see the market, and it is important that you understand it. In the world of big business, markets are often classified as vertical or horizontal. While doing consulting for a large corporation in the photography industry,

I was privy to market research done by one of the most accomplished market research firms in the United States. No, I can't say which research firm, due to a confidentiality agreement. It was commissioned to study the publication photography marketplace in the United States only. The results of its study were impressive. Here's a summary of the findings:

There are two types of markets that are purchasing photography for publication. One is composed of companies in the creative fields. That group includes businesses from the advertising and editorial segments of the industry, like advertising agencies, publishers, and graphic designers. There are approximately 257,000 such businesses. Some are big corporate entities and some are small, personally owned businesses. Together, these businesses buy more than $1.6 billion worth of stock photography every year. The other group is the noncreative sector of business and industry, which is not engaged in the business of creative communications. Out of 10.3 million total businesses, there are approximately 2,100,000 such businesses, which buy $2.1 billion of stock photography annually. That puts the publication photography business at $3.7 billion in annual sales, generated by a total of 2,600,000 companies. It was also estimated that the worldwide assignment photography business was twice the size of the stock photography business, i.e., $7.4 billion. That puts the entire market for publication photography over $11 billion. Even if the study had a margin of error of plus/minus 50 percent, the market is huge.

HUGE DOES NOT EQUAL EASY

A huge market is not always an easy market to penetrate. By comparative analysis of the two types of markets we find that the creative companies comprise about 7 percent of all businesses buying photography for publication. And they are buying about 33 percent of all publication photography

that is bought. Those percentages tell us that there are great sales opportunities in what can be described as a vertical market—an inch wide and a mile deep.

The noncreative companies, which make up 93 percent of all publication photography buyers, are accounting for 67 percent of publications photography sales. Unlike creative companies, which are readily identifiable, these noncreative companies are difficult to identify. They comprise a horizontal market—a mile wide and an inch deep.

Each type of market offers challenges to anyone who is attempting to break into them. The vertical market, which is rich with easily identified prospects, is the one most pursued by photographers and stock agencies. Consequently, the competition is severe. The horizontal market, being difficult to identify individual prospects, is the least pursued but the hardest in which to find prospective customers.

Obviously, each market type has found its source of supply for photographers and photographs. The creative side does not have to search for photographers. They come looking for business. But the noncreative side has to go out and find its photographers and photographs. The enterprising photographer who can identify photography using businesses in the noncreative sector will find himself in a world of clients that use photography on an irregular basis but have few photographers competing for that business.

SPECIALTIES

The word "specialty" is misunderstood when it comes to photography. Many photographers who concentrate their work in a specific market segment will declare that their specialty is either advertising, corporate, or editorial photography. While there is no rule book that prohibits such a

declaration, I believe that it is self-defeating when a photographer thinks of himself in those terms. It is like psychologically cutting yourself off from sales in other segments. We all can imagine images that we might take that would sell in all four of the market segments for publication photography. Look back at figure 1 in chapter 1. That image was used in an editorial and an advertising context. It could be used in a corporate or merchandise market segment application as well. You will make more money by selling photographs for publication to all four market segments than to only one. Never limit your thinking about the markets you can reach.

The list below consists of the major specialties that photographers engage in.

- Aerial
- Agriculture
- Animals
- Architecture
- Automobiles
- Beauty
- Documentary
- Fashion
- Fine Art
- Food
- Forensic
- Glamour
- Industrial
- Landscape
- Marine
- Military
- Nature
- People
- Performing arts
- Sports
- Still Life

- Travel
- Underwater
- Wildlife

Specialties are often grouped. A photographer might do beauty, glamour, and fashion. An underwater photographer who works in the oceans is also a marine photographer and, if he takes photographs of sea animals, he is also in animal and wildlife photography.

Specialties can also be subdivided. Architectural photography includes building exteriors, building interiors, and landscape architecture. Sports can include football, soccer, tennis, baseball, etc. Still life can include food, flowers, and products. Of course, if you limit yourself to one or two narrow subspecialties, you will be limiting the market for your work. Most photographers develop expertise that allows them to work in several specialties or in specialties with substantial subsets to ensure them a large enough market to provide sales that are extensive enough to sustain the business.

SELECTING A SPECIALTY

Selecting one or more specialties can be done on the basis of the nature of your circumstances. In chapter 1, you learned to evaluate yourself and to identify the kind of photography that you do best. In that process, find out what you are naturally inclined to photograph. Your likes, dislikes, education, environment, and other factors come into play when making a decision about specialties.

Another element in natural selection is your location. If you live in an agricultural area, it might lead you into that specialty. Living in a major metropolitan area usually offers plenty of opportunity for sports photography at the college and professional levels. Being near

a seacoast or wilderness area can lead you to marine or wildlife photography.

If your likes and dislikes are not complementary to the natural choices you have, you ought to carefully consider whether you should follow your impulses. Maybe you have to change your environment to be able to exploit your innate and developed talents.

THE PHOTOGRAPHY UNIVERSE

Capitalizing on the opportunities presented in chapter 1 requires that you understand the universe of photography and the best place for you within that universe. You have to understand how specialties and market segments present multiple opportunities. More importantly, you have to determine which specialties will allow you to enjoy yourself while you produce work to be used in the different market segments. Of course, you will have to have a thorough understanding of how business is done and how opportunities can be found and exploited in each market segment. The remainder of this book is dedicated to giving you that knowledge.

Chapter 3

Deciding on a
Business Model

As a publication photographer, you will have to decide whether to engage in assignment photography, stock photography, or both. Those are the two business models for photography. Deciding which path to follow is a matter of understanding the effective differences between them.

Assignment photography is made-to-order work. You don't make photographs until someone orders them. Consequently, someone else pays for the photography work that you do within a short time after completion. The commissioning party pays all of the costs of production of the photographs.

Stock production photography is self-assigned work. The photographer must cover the production costs in addition to the related overhead. This requires having enough capital on hand to meet those costs. The only way that you can recover your costs is by the future sale of your stock images.

ASSIGNMENT PHOTOGRAPHY

Most professional photographers are engaged in assignment photography, because it is the simplest and quickest way to generate an income from publishing your photography. But don't let the words "simplest" and "quickest" deceive you. Getting started and achieving success in the assignment photography business is a challenge that is not met by some of the people who take it on. Certainly, many do get started in the assignment photography business, but success is usually years away from that starting point.

To succeed as an assignment photographer, you first have to have those technical and aesthetic skills that were mentioned in chapter 1. But those skills alone are not enough to make you successful. Assignment photography is a business, and, like any business, success requires that the business owner has a solid grasp of both business principles and practices. Business principles, those that apply to the operation of any business, include the ability to make and implement strategic, marketing, and financial plans. The proper use of contracts and licensing agreements are two examples of business practices.

Business skills like financial and personnel management, project management, selling, and negotiating are also requirements for success in any business. The publication photography business is no different from any other business. You have to have the skills required to run the business if you are to succeed.

Later you will delve into topics related to running a business in enough depth to provide you with a good insight into what it takes. You will also be given references to other books that you can read in order to sharpen your business acumen.

Assignment photography is usually the purview of the full-time professional photographer because clients generally want assignments completed when they want them, not when you will be available to do them. However, it is

possible to run a part-time assignment photography business. Running a successful part-time assignment photography business requires all the same knowledge and ability that running a full-time operation requires.

Assignment Photography Options

There are three assignment photography business options: stuio-based photography, location-based photography, and a combination of both. Which one you should engage in depends on your specialties. If you are a wildlife or sports photographer, there is little need to have a studio. If you are a fashion or food photographer, there are good reasons to have a studio. Studio photographers can always work on location by moving their equipment. Location photographers don't own studios, so they do not usually pursue that kind of work. Of course, almost any suitable space can be used as a studio, so the location photographer can set up in rented space. Many urban areas where there is a demand for commercial photography will also have rental studios, complete with lights, available for the traveling or location photographer to use. Photographers who own studios often rent their studios to other photographers as long as the work to be done is not competing with the studio owner's work.

Maintaining a full-time studio is an expensive undertaking. It requires a substantial and consistent volume of business to pay that overhead. That is why most photographers choose the location model and rent studio space when they require it.

STOCK PHOTOGRAPHY OPTIONS

Stock photographers make photographs in advance of a user's need for them. They build up an inventory of photographs that could be suitable for many publications.

This is unlike the assignment photographer, who makes photographs to order.

Photographers accumulate stock photographs in one of two ways. Either they purposely create them, or they select photographs for inventory from those that were taken on assignments but not needed or used by the client who commissioned the assignment. The first method is known as *stock production*, and the latter method is known as *repurposing outtakes*, which are the photographs that are taken out of the work product and not retained by the client. The photographer keeps them on hand in case another party develops a purpose for them. At that time, having not been used for the original purpose for which they were made, the photographs are repurposed for another use.

Production or Outtakes

The major differences between the images produced for stock and those repurposed for stock is the cost of production. The stock photographer must finance the shooting of produced stock images. That means he has to have enough working capital to do it long enough until the work generates sales to recover those production costs. On the other hand, assignment clients pay for the production costs of assignments, so photographers do not have to pay those costs. On the basis of production costs, whether to choose to accumulate stock photographs by your own paid production or by client paid assignment production seems like a no-brainer. Who doesn't want to save money? No one, I expect.

There is another difference between the two methods of creating a stock photography inventory that has a substantial bearing on the diversity of the collection and therefore a substantial effect on the ability to make sales. Assignment clients usually want photographs for very specific purposes. That specificity can mean that photographs

taken on assignment will have little, if any, use in the stock photography market. That is why most assignment photographers do not derive much income from stock photography. It is also why most photographers who receive substantial revenues from stock photography produce stock photographs on their own.

Marketing Stock Photography

The stock photographer has two ways to market his photography. One way is to set up a business with all the features necessary to bring a product to market and to capture the revenue stream from that effort. The other way is to simply produce the stock photographs and let another party take care of marketing, licensing, collection, etc.

Deciding to market your own stock photographs means that you have to be able to run a business just as if you ran an assignment photography business. As previously mentioned, those skills are addressed in future chapters.

There is a way to market stock photography that does not require the same level of business acumen that the assignment photography or self-marketing stock photography businesses require. That way is to use one of the many existing businesses that market stock photographs for photographers who choose not to do it themselves. These businesses are usually known as *stock agencies*. They acquire photographs from a variety of sources, then they store them, market and license them, collect the licensing fees, and take a share of the sale and return the rest to the photographer. The share they take is usually somewhere between 40 and 60 percent. Is it worthwhile to contract with an agency? Probably, because it is very difficult for a photographer to provide himself with the range of services that agencies provide and keep the expense of doing so at a percentage of revenue equal to or less than that which an agency takes for its services.

Stock photography is a very competitive business, and that means that finding a stock agency to represent your work is not easy. You have to be producing photographs with very good aesthetic and technical quality to be accepted for representation by a successful stock agency. The stock agency would rather represent one hundred good photographers than one thousand mediocre ones. Mediocre photography has little chance of selling in today's market, because there are plenty of top-notch photographers already supplying demands. To break into the stock photography market, you have to be at least as good as the average top-notch photographer.

Stock Photography Approaches

Stock photography has two approaches: *rights managed* and *royalty free*. Since the photographs are copyright-protected expression, the right to use them lies with the copyright owner. Except in extreme cases, that ownership is usually vested in the photographer. When a person is employed to make photographs as part of his job, the copyright to his photographs belongs to his employer. When a person makes photographs as an independent contractor, he owns the copyright to his photographs unless he transfers it to another party by one of several means available. Payments for the use of copyrighted materials are generally referred to as *royalties*. The use of copyrighted materials is licensed in the form of rights or permissions to use the materials. The rights to publish photographs are licensed to users for a royalty payment.

The terms "rights managed" and "royalty free" are used to differentiate between two ways of licensing stock photographs. Unfortunately, the terms are not as well suited as one would like for describing the models.

Rights-managed stock photography is licensed use by use. Each use has a fee (royalty) assigned to it. Uses can be very broad or very narrow. *Royalty-free licensing*, instead being divided and priced use by use, is divided by the maximum size in which a published photograph can be reproduced, but there is no restriction on the uses or the number of times or ways that the photograph can be reproduced. What makes the words "royalty free" confusing is that the uses have a fee (royalty) attached to them. Those uses are not royalty free. They can be much less expensive than using rights-managed photographs because the number of times the photograph can be used is unlimited. Rights-managed photographs usually have some usage provision attached to them that prevents either multiple uses or perpetual uses of the photograph. So the main difference between rights-managed and royalty-free stock photography is the price and the variety of uses allowed for that price. Both models provide for some management of the rights and both are licensed for a royalty. That being said, the business is what the business is, and the inconsistencies of the business are beyond your and my control.

Which approach is for you? I can't answer that for you. It depends on your photographic collection, your personal preferences, your agency's opinion, and your production capability. But you ought to know this: Royalty-free photography has captured about 65 percent of the marketplace in terms of volume of sales, but rights-managed photography is generating about 50 percent of all stock photography revenues even though it generates only 35 percent of the sales volume. So royalty-free sells in greater volume but earns a lower fee per sale, while rights-managed sells in lower volume but earns a higher fee per sale. Which is best? Neither is best, because each serves a different class of buyer. That multiclass buyer pool probably means you ought to look at having photographs in both types of collections.

PREPARATION IS OVER

The first three chapters of this book were meant to give you background and food for thought as you read the remaining chapters of this book. Knowing which business model is best for you is a matter of analysis that is connected to knowing your photographic capabilities and knowing the general nature of the marketplace. Now that you have that under your belt, it's time to move on to learning about how to get your photography published.

Chapter 4

Finding
Advertising
Clients

In the photography business, the word "advertising" is usually understood to mean creative works that will be published in media space that is purchased by the advertiser, such as in magazines and newspapers. The word "promotional" is usually understood to mean creative works that appear in unpaid media space, like publicity announcements and brochures. That's all well and good, but I want you to think about the words "advertising" and "promotional" differently. If you can, you will start to see the advertising segment of the photography business as a very diverse range of opportunities.

My computer has a dictionary built into it. I used it to clarify the difference between "promotional" and "advertising." The word "promotional" means "related to the publicizing of a product, service, venture, or organization for the purpose of increasing sales or public awareness." The word "advertising" means "drawing attention to a product, service, or event in a public medium in order to increase sales or attendance." What is the difference between the two definitions?

Not much. For all practical purposes they are the same. The phrase "in a public medium" is included in the definition of "advertising" but not in the definition of "promotional." Well, in my opinion, any medium that is viewable by the public is a "public medium."

As mentioned, I want to orient your thinking to treating advertising and promotional photography as essentially the same thing, because that is what they are. For the purposes of this book, the words will be used interchangeably. However, the word "advertising" will be used more prevalently.

ADVERTISING APPLICATIONS

There are a variety of advertising applications that use photography. If you intend to publish your photography in the advertising segment of the marketplace, you must understand what these applications and are and how they can relate to one another.

Advertising is usually conducted with a campaign strategy. A typical campaign might use several different applications in a coordinated approach to promote an advertiser's interests. When more than one advertising application is used in a campaign, the most prevalent one is considered the primary one and associated applications are secondary and often referred to as *collateral uses*. For example, a company that is running an advertising campaign in national magazines might choose twenty different magazines to run its ad in. Additionally, it might print brochures and distribute them by direct mail as well as create a point-of-purchase display. The magazine ads would most likely be the most expensive part of the campaign. That publication use would be considered the primary use and the other uses would be considered collateral uses.

Below, you will find a description of each of the most common forms of advertising. These are the applications in which photographs are published. As such, they must be understood if you are to succeed in publishing your photographs in this segment of the market.

Advertorials

Advertorials are advertisements that are disguised to look like editorial articles. They usually consist of paragraphs of text with accompanying photographs illustrating the text. Advertorials are labeled "advertisement," usually in very small print, on the pages of the publication containing them. They are most common in consumer newsmagazines, business magazines, and trade magazines.

Since the ads are made to look like articles, the kind of photography that they employ looks like typical editorial photography, and not like the slick illustrations used in regular advertisements.

Billboards

Billboards need no explanation, especially if you drive along the highways or drive into or out of any city in the United States. Roads are often lined with billboards offering all sorts of things, from hotels and fast food to auto repairs and local attractions. Billboard advertising is very popular because it is simple and effective. A simple message with a memorable image is the rule of the day.

Brochures

Brochures come in all shapes and sizes. They are often used as a collateral application to print ad campaigns. Brochures are usually distributed by direct mail, by Internet download,

or by placement in publicly accessed spaces like hotels, conference centers, schools, hospitals, and retail outlets.

Catalogs

If you ever bought anything from a mail-order catalog, you know just how effective catalogs can be at selling you something. Catalogs not only make you aware of a product, but they also provide you with the opportunity to act on that awareness by purchasing the product. They are unique in that they promote a product, then try to sell it to you. Like brochures, catalogs can be in print or on the Internet.

Circulars

If you get a Sunday newspaper in most urban areas, you find that it is full of circulars. These printed pieces combine the features of print ads and brochures. Some even have the features of a catalog because they make it easy to order the items listed in the circular.

Direct Mail

One of the most exploited means of advertising is direct mail. It is an application that was invented to improve the chances that you will see an advertiser's message. You might quickly pass by that advertiser's ad in a magazine or newspaper. Or maybe you don't receive the magazine or newspaper carrying the ad. By mailing a promotional message to you, the advertiser is assured of two things: First, you are likely to receive the message and look at it. Most consumers at least *look* at all their mail. Second, if you did see the print ads the advertiser is running or the brochure

it is circulating, the advertiser reinforces the message with a direct approach to you.

Magazine and Newspaper Display Ads

There is no need to explain what these are. What you have to keep in mind is that these ads can be either trade or consumer ads. Trade ads are aimed at businesses and consumer ads are aimed at individual consumers like you and me.

Online Display Ads

Ads are literally popping up all over the Internet. These pop-up ads are so annoying to people that the makers of popular Internet browsers have included features in their programs so that the user can elect to block these ads. But advertisers are not deterred from finding ways to advertise to us on the Internet. Just visit a camera manufacturer's site and click on one of the many icons in the shape of a banner stating "More information" or "Learn more." You will almost definitely be taken to an online promotion for that manufacturer's product(s). From the Web sites of automobile dealers to those of regional zoos, most sites contain advertising, and usually photographs.

Package Design

When you buy a product that comes in a package that will be on display for sale, the package is usually designed to create buyer interest. Package design applications can employ photographs. Usually those photographs will be consistent with the photographs that were used to advertise the product. That kind of consistency contributes to branding the product in the consumer's mind. Package design is rarely a

standalone application. Most often it is a collateral part of coordinated applications.

Point-of-Purchase Displays

Point-of-purchase displays are usually employed for new or revised product introductions. Most often they are sitting on the counter where the product you want to buy is being sold. They are there to draw the shopper's attention to something that is new. Shoppers often buy out of habit, and so they do not actively seek other, newer products. The point-of-purchase display is intended to get them to think, if even for just a second, about an alternative.

Transit Posters

Marketing firms have learned one thing for sure: The traveler or commuter can be a captive audience. We all look around a subway or bus, if only for a moment. In that time span we are likely to see ads for a variety of products. When we walk from the airport curb to the departure gate, we are treated to a gauntlet of ads. When we wait for our ride on a train, we see the advertisements lined up on the walls or on the fencing that lines the station. Yes, transit posters are a popular and effective form of advertising.

ADVERTISING SEGMENT BUSINESSES

All the advertising applications listed previously are simply vehicles for carrying a message. Unlike with editorial publications, understanding the advertising vehicles is not the key to getting published in the advertising segment. The way you get published is to sell yourself to the businesses that create the advertising and promotional applications

that were previously described. You have to convince them that you have the creative ability to make photographs that make people want to buy something. Let's examine each of the types of businesses in the advertising segment. Later in this chapter, we will consider how you can find these businesses for your prospect list.

Advertising Agencies

An advertising agency's primary role is to create advertisements, which are creative messages aimed at selling something. The classic advertisement consists of three creative elements: written copy, imagery, and design. A copywriter supplies the verbal message, a visual artist (often a photographer) supplies the imagery, and an art director puts both of those elements into a designed formatted for publication. Advertising agencies use both assignment and stock photography, but assignment photography is more prevalent.

Many advertising agencies also incorporate the many other services that are offered in the advertising segment into their operations. Those agencies are often referred to as "communications firms," but not always. An established agency may not want to change its name when it expands its services. The important thing to remember is that a name is just a name. It might not fully describe the services a business offers. You have to find that out the old-fashioned way: Ask for the information.

Public Relations Firms

Public relations (PR) firms are involved in the professional maintenance of a favorable public image for companies and individuals. For the most part, their main tools are words and photographs. The messages they communicate are a soft sell when compared to the hard sell of advertising. For example, an

ad for Hertz might proclaim, "We Are #1" over a photograph of a Hertz car in an exotic location in an effort to make you want to work with the top of the field. But a press release for Hertz might convey how Hertz's not-for-profit foundation is providing graduate fellowships at the nation's top universities to scholars in the physical sciences. The PR release is intended to induce you to prefer Hertz because some of the money you spend for renting its cars is being put to good use. The press release is likely to have some photographs accompanying it.

The PR firm might also prepare a story about Hertz's fellowship program, complete with photographs to be submitted to magazines and journals that are read by the academics who are eligible for the fellowships. Remember, they rent cars too.

PR firms primarily use assignment photography as a first use or reuse. While they might occasionally use stock photography, this use is minimal because the messages they communicate are very specific. Thus, the photographs they need are specific to one aspect of a particular company or individual.

Publicity Agents

While they prefer the title of "publicist," the fact is that publicity agents exist to do two things: get a company or individual good publicity, and control and counter bad publicity. Entertainers and sports figures often have publicists. Mostly they work the media in an effort to keep their clients in the public eye. They use photographs because they know that a well-placed, flattering photograph is worth the proverbial one thousand words when it comes to drawing attention to someone. Publicists are selling image. When you sell image, you need images, but publicists are particularly choosy about the photography they use. For the most part, that photography is shot by carefully selected photographers with a talent for making the subject look very special and appealing.

Graphic Design Firms

Graphic designers have the challenging job of making media space look good. They are the ones who do the creative arrangement of the elements that are brought together to convey meaning. I include Web site design as part of graphic design. The creative elements can consist of one or more of these items: text, illustration, photographs, graphic art (like charts and graphs), paper and ink stocks, and colors. Design firms are among the most prolific users of photography. Those photographs end up in annual reports, magazines, books, catalogs, brochures, Web sites, circulars, calendars, greeting cards, and other applications. Graphic designers buy more photography than advertising agencies or any other advertising segment business. They use both assignment and stock photography. They probably use more stock photography than all the other advertising segment businesses combined.

FINDING ADVERTISING SEGMENT PROSPECTS

Finding prospects in the advertising market segment is easier than finding prospects in any other segment. The reason for that is because those businesses exist primarily in and around urban centers. That means that you can find them in local business directories like the Yellow Pages, chamber of commerce membership directories, and local association directories. If you are ready to solicit work from national clients, the task of finding prospects is more difficult, but there are ways to do it.

Classified Telephone Directories

Also known as the Yellow Pages, classified phone books for all the major cities in the United States can be purchased

from the companies who publish them. You can look under headings like Advertising, Designers, Graphic Arts, and Publishers. The Yellow Pages for the telephone area I reside in covers one suburban Philadelphia county. It lists more than fifty advertising agencies that are within ten miles of my home office. That means fifty prospects for photography.

Your locale might be served by one or two directory publishers, who most likely publish the business directories in other locales. You can find out how to contact those publishers in the directories, which they have probably already delivered to you free of charge.

Trade Association Membership Directories

Trade associations have membership listings that are usually available to the public. Sometimes those lists are available right at the association's Web site. Here are some of the more popular associations and their Web sites.

- American Association of
 Advertising Agencies *www.aaaa.org*
- Outdoor Advertising
 Association of America *www.oaaa.org*
- National School Public
 Relations Association *ww.nspra.org*
- Public Relations Society
 of America *www.prsa.org*
- American Institute of
 Graphic Arts *www.aiga.org*
- Graphic Artists Guild *www.gag.org*

But you should not stop short with the above list. You can do your own Internet search and turn up many sources of prospects.

Industry Directories

There are a number of print publications that contain lists of prospects. A visit to your public library's business reference section will usually be productive in this regard. Publications like *The Advertiser Red Books*, *The Agency Red Books*, and the *Thomas Register*, which all offer information on a variety of industries, are often found in large metropolitan libraries. However, many of these books are quickly being turned into Internet applications on the Web.

Finding prospect lists on the World Wide Web has become easy with the advent of Web sites like MediaFinder (*www.mediafinder.com*), Ulrich's Periodicals Directory (*www.ulrichsweb.com*), and Advertising Redbooks (*www.redbooks.com*), which are online directories where you can look up agencies.

Trade Press

The advertising trade press is a good source of leads. That trade press, whether regional or national, usually reports what agencies have received which advertising campaign contracts. That news is of double value because as you identify the prospects, you learn who their new clients will be. If the clients sell products or services that are compatible with your photography, you are one step ahead of the game.

Many urban areas have business newspapers that report advertising news. Regional and national media newspapers frequently run stories in their business sections about what advertising agencies have been awarded business by substantial companies.

Web Sites

What isn't reported in the trade press is usually otherwise discoverable. Once again, the Internet comes to the rescue.

Any advertising segment business that does not have a Web site is probably not worth working for. Those that have Web sites usually tell you everything you want to know about their business. Often, they list who their clients are and display ads from some of their current or past campaigns. When you have the opportunity to see what kind of photographs your prospects have used in current or previous campaigns, you will have a good insight into what kind of photographs you ought to have in your promotional materials and portfolios that will be used to solicit those prospects.

RESEARCHING ADVERTISING PROSPECTS

There is a major difference that separates researching other segment publishers' photographic needs from researching the needs of businesses in the advertising segment. That difference is simple. The photographic needs of advertising segment businesses are determined by the agencies' clients. One day they may need photographs of automobiles, and the next day they may need photographs of cosmetics. How do you determine the need? Generally, you ask them or they tell you when they solicit your work.

You can get good insights into what kind of photographs they will need by visiting prospects' Web sites. There you will often find their client lists, and ad agencies will frequently display images of the ads they have recently created. That insight will help you prepare to approach them for a meeting to show your work. For example, if an advertising agency has a restaurant as a client, you can be sure that they will be interested in your food photography, your environmental portraits of people in work settings, and your photographs of restaurant interiors or similar spaces. When it comes to selling a prospect on your services, every bit of information you can gather will be an asset in turning the prospect into a client.

ASSIGNMENT AND STOCK OPPORTUNITIES

The use of stock in the advertising segment is usually limited to the advertising agency that is working on the low-budget account whose photographic needs can be met with generic photographs. When a company is spending hundreds of thousands to millions of dollars for the purchase of media space, it is likely to spend the money to have the photographs it wants created exclusively for the advertising campaign. But there are numerous low-budget advertising projects that use stock photography.

Likewise, PR firms and publicists usually need photographs that are made just for the purposes of the communication they will issue. Since they are trying to enhance an image of a specific person or company, they will want photographs of that person or some aspect of that entity's operations.

The big users of stock photography are the graphic design firms. In the process of creating brochures, circulars, Web sites, and other promotional applications, they use many generic photographs. For example, if a hotel is located near a national park, it is likely that the hotel's brochure will have a photo of that park. You can be sure that the hotel is not going to pay assignment fees to get that photograph when they can buy it from a stock agency or photographer for a tenth of the price of an assignment.

Stock photography offers the semiprofessional photographer a way to publish in the advertising segment of the business. Advertising firms are not hiring semiprofessionals to do assignments. Too much is at risk to take a chance that an assignment might have to be reshot for any reason. Quality advertising firms only hire qualified professionals. But the story changes dramatically when it comes to using stock photography. No one cares who took the

stock photograph selected for use. There is no risk. The buyer has the finished product in his hands from the start.

There is also no way to know what kind of photograph will come from an inventory of stock photographs. You will recall the photographs of the girl with the horse in figure 1, chapter 1. Subsequent to the first advertising campaign it was used for, it has been licensed several times for use in advertisements.

Today, most stock photography is licensed over the Internet from Web sites that allow selected images to be downloaded ready for use. Speed and convenience of selection and acquisition are what buyers want. For the photographer, that means he is much more likely to be able to sell stock photography through an agency with Internet marketing and licensing capability than he can on his own. But remember, before you head off looking for a stock agency to represent your work, you should reread chapter 3 for advice on that topic.

Chapter 5

Finding
Corporate
Clients

The most nebulous term in the publication photography business is *corporate photography*. Some people call it "corporate-industrial photography." I have heard people define corporate photography as that which is done for corporations. That definition simply does not work, because the vast number of advertising segment creative communications firms and editorial segment publishers are corporations. We do not call the work we do for those companies corporate photography.

On the other hand, suppose a large corporation has an in-house advertising department. We should consider that corporation's advertising department to be part of the advertising segment of the industry because it is doing the same work that any independent advertising agency is doing. So we can see that it is not the form of the business that dictates its segment classification; it is the purpose to which the photography is put that determines the segment classification. If the photography is done for advertising purposes, it is advertising segment business, no matter what kind of entity is preparing the advertising.

Corporate photography is used to enhance the image and/or status of a company. It doesn't matter whether the company is incorporated or not. A partnership or a sole proprietorship has the same needs for photography that a corporation does. Maybe corporate photography ought to have been called *business photography* or *trade photography*. After all, it is about photographing businesses, and there are millions of businesses around the world.

ONE MILE WIDE AND ONE INCH DEEP

You will recall the concept of a horizontal market presented in chapter 2, Market Overview. Unlike the vertical markets of the advertising and editorial segments, the corporate segment includes many diverse businesses offering every product and service you can think of. Chances are, there is a prospective corporate client within walking distance of your home, office, or studio. All too often, photographers think of the corporate segment as being composed of big businesses. Not true. Prospective corporate segment clients can be very small or very large enterprises.

Within one mile of my office, there are many businesses that are corporate photography prospects. One is the Ace Hardware store. Ace Hardware is a cooperative corporation. That means it is composed of many independently owned stores that have an umbrella organization for marketing and supply acquisition. The Ace Web site (*www.acehardware.com*) uses photographs from Ace stores. That means that I might be able to sell Ace Hardware some photography of its store near me. Within ten miles of my office is the headquarters of Sunoco, one of the nation's largest oil companies. Its corporate communications department uses photographs regularly in an effort to improve the image of the company. Those two

examples show the diversity of the local corporate market—from a small retail operation to a huge international company.

THE BUSINESS IS ALL AROUND YOU

I was once asked to speak to a small photographers' organization. It had about forty members. All were complaining that the business was terrible, and as a result, competition was fierce. To prepare for the talk, I researched the area that those photographers serviced. What I saw was a fifty-mile radius in which there were a total of about sixty creative businesses. Now imagine forty photographers looking for business from the same sixty prospects. No wonder it was cutthroat business. There was not enough of a prospect base to support that many photographers. Then I researched how many noncreative businesses there were in the same area; the number was about two thousand.

In that market area, maybe one business in ten uses photography. That's an educated guess, since I have no statistics but my own experience to support it. But, if my guess is correct, you could go to an industrial park where a hundred businesses are located, and after you knocked on every door, you would find ten photography users. Some of them will acquire their photography through the services of a creative business like an ad agency or a design firm, and others will acquire it themselves. But if the photographers I spoke to could identify the 10 percent of the two thousand that used photography, they would potentially have another two hundred prospects to add to the sixty they were fighting over. Two hundred sixty prospects would support forty photographers better than sixty would.

The problem is the amount of time that it takes to identify the photography users in the horizontal market, and then determine which ones acquire their work directly.

However, there are ways to exploit the horizontal market, if your particular kind of photography fits that market.

Use Membership Directories

When it comes to finding corporate businesses and institutions, you can find lists of individuals that you can qualify as prospects, but it's more difficult than finding names in the vertical market. This is because the people you want to find are most often employees of businesses that do not want their names readily available, primarily because they are trying to avoid being approached by salespeople. However, many of these people are members of organizations that have membership lists. Some organizations will sell copies of their membership directories; others will not. Popular organizations such as the International Association of Business Communicators (IABC), The Association for Women in Communications, and the American Society of Association Executives (ASAE) all represent corporate communications workers. If you can get these or similar lists without too much trouble, you ought to. They can be helpful when you are trying to find prospective clients.

Visual Sightings

Fortunately, there is a more efficient way to find prospects in the horizontal market. The easiest way is to keep your eyes open and do what people pay you to do: Look around. Imagine that you are outside, moving about town or the countryside. Take notice of possible prospects. You see a hospital. You can be sure that it uses photography in a variety of ways, with PR being one of them. If it is a large hospital, it may have a staff photographer; if it is a smaller hospital, the chances are that it does not. The same is true for educational institutions. Next, you pass an industrial park of small manufacturing and service

businesses. You stop and copy down the names of the companies from the list so conveniently placed on the sign at the entrance. Chances are that some of these businesses use photography. You drive down that strip that leads out of town and you realize that along fifteen miles of that road, you passed three oil refineries. Maybe their home offices need photographs at their plants. If you want to find prospects in the horizontal market, you can find them all around. You just have to look for them.

Calling the main office and asking if there is a communications or public relations department in the company can qualify these prospects that you found along your drive. You can get the name of the person who is in charge of the department and/or the names of those who work in the department and hire photographers. It is amazing how much information you can get from a phone call if you just ask nicely. I always like to ask for help. Most people like to help, if it isn't too much work. It makes them feel good, and I am happy to provide them with the opportunity to be helpful. You should also be on the lookout for materials published by businesses. Company newsletters, magazines, and brochures abound. Businesses make press kits, use executive publicity photographs, record events, and more. Remember what you read above. This horizontal market buys $2 billion of photography a year. You can sell them some of it.

Needless to say, you should also visit these prospects' Web sites. Most likely, it will give you a look at some of the ways that they use photography. If they do not use photography, it is a signal that you ought to be selling them on the idea of doing so. Their Web site might have the information about the communications department that you need. Sometimes you can sign up for their promotional materials. If you can, you ought to, because when they arrive in your mail, they are a messenger telling you what kind of images

you have to show the company when you promote yourself and make that inevitable sales call.

Here are two true examples of what I have been suggesting: Throughout the course of driving around my region on location jobs, I passed a number of oil refineries. I never paid much attention to them until one day, as I was driving by one of them, there was a film crew outside taking some shots of the main gate. It was like lightning striking me. Companies use photographs of their oil refineries. It had never dawned on me. The next day, I recalled all the regional refinery locations I could remember; there were seven prospects to qualify. Another day I was driving down the main avenue, which parallels the local port facilities near where I live. There was a large, new-looking ship being unloaded. Well, the lightning bolt hit me again. I wondered what company built and/or owned the ship, and if they ever photographed their ships in port. The next day, I did some research and identified all the ship-building yards in the United States; there were very few. In a short time, I had qualified the prospects in the oil and shipbuilding industries. Then it was time to promote myself to them.

CORPORATE PUBLICATIONS

Most businesses have two challenges when it comes to marketing. One is to market their products or services, the things that people pay for. The other is to market the company itself, that is, to make the company name a brand name and to make it not only highly recognizable, but also highly memorable. Branding is a real challenge for a business. People need or want products and services, but they don't need or want the companies that make the products or supply the services. Companies are second to their offerings in the consumer's mind.

54

A good example of corporate branding efforts are the sponsorship that companies provide for events, teams, etc. When a company sponsors the Olympics, an automobile racing team, or anything else, it is selling the company, not specific products or services. Companies spend many millions of dollars in that effort every year. The desire is great, and that means that there are publishing opportunities for you.

Businesses rely on certain types of applications and efforts to promote the company and make its name a brand. It is important to understand the nature of the application and what the company is trying to accomplish, because your photographs must complement those purposes.

Annual Report

A company's annual report has one objective: to convince investors that the company is worth either investing in or maintaining a current investment in. In its simplest form, an annual report is just financial statements. After all, investors are primarily interested in the financial performance of a company. But most annual reports do more than present numbers. They present the company, its facilities, employees, managers, products, and services, its community outreach, and any thing else that can lead to a better impression by readers.

A company is likely to pay more for its annual report photography than for any other photographic needs it has. It knows the annual report is the most important vehicle it has as part of its effort to maintain its financial health. In a way, the annual report is the company. The photography in the report has to portray people and things in a way that the company can be proud of. Just as the financial statements relate how the company's finances look, the photographs have to portray how the company itself looks.

The Image Brochure

Like it or not, we live in a world where image is important when you are trying to succeed in business. That is because everyone know that success breeds success, and if you can create a successful image for your company, you can increase your chances of making sales of your advertised products and services. The image brochure will usually rely heavily on photographs, because space is limited and images can have greater and quicker impact than words in a brochure. Remember, the brochure is intended to make you remember the company, not to sell its specific products or services.

A good example of a corporate image brochure is the kind produced by many automobile manufacturers. DaimlerChrysler Corporation manufactures Chrysler, Jeep, and Dodge automobiles and trucks. It also operates Chrysler Financial, a lending and leasing company, and Mopar, a line of auto parts. A Chrysler Motors brochure, like its Web site, will display all of its asset companies with glimpses of the products they offer. The purpose is to make the reader believe that Chrysler Motors is a superior company, so it must have superior products.

Big companies are not the only ones to have image brochures. One block from my office, there is a small financial services firm that is independent of all the big-name players in that field. It has attractive office space and a staff of five, all of whom have excellent credentials. The firm can set you up with life or disability insurance, an annuity, money-market or mutual funds, a trust fund, and more. Its image brochure mentions those products in a list without details. It portrays the professional look of the offices and staff. But most importantly, it carefully articulates the qualifications of its advisers along with photographs of each that make them look like confident, successful, trustworthy people. The company is not selling its products. It is selling itself through its

advisors, which it and most of its prospects see as the most important component of a financial services firm.

Company Magazine

Only the largest corporations publish magazines, because the cost is so high that most companies cannot sustain the expense in a competitive business environment. However, those magazines do exist, but you have to look for them because they are not always obvious.

If you fly using any of the major airlines, you have probably seen their company magazine "in the pocket of the seatback in front of you," as the flight attendant will usually say. It is full of lifestyle and travel articles and has little to say about the company. Of course, if you want to travel to one of the places it runs articles about, they hope you will fly their airline.

Another example of a company magazine is *Mopar Magazine*. As mentioned above, Mopar is the auto and truck parts manufacturer owned by Chrysler Motors. Mopar sponsors racing teams. The magazine concentrates on the auto racing sport and offers features on drivers and crews, tech articles, and listings of where Mopar events are taking place across the country. The magazine sells the name Mopar to people who like auto racing, because those are the people who are most likely to be fixing their own automobiles and therefore buying parts.

Public Relations

As part of a routine effort to keep build their images in the public's eye, companies usually maintain an intensive public relations effort. They might employ a PR firm to orchestrate the effort, or they might have a communications or public relations director on staff. PR can be as simple as a press

Figure 2

release or as complicated as a large brochure. PR usually touts the virtues of a company or its activities. It is usually a word product that may or may not be supplemented by photographs. When photographs are likely to improve the chances of the PR message being published, photographs will be used. Usually, those photographs are specific to events or people, and usually they are made on assignment. Figure 2 is a photograph that I made of a regional rail line's commuter station to accompany a PR effort to improve the subsidies it received from state and local governments. The subliminal message of the photograph was emphasized by the accompanying caption and text. That message was that mainstream voters ride the trains, and lower subsidies meant higher fairs and fewer votes for those who might cause fares to be raised. As I recall, the text said it like this: "The average commuter using the rail line is between twenty-five and fifty-five years old and seeks an economical means of commuting between the suburbs and the city." That is an indirect way of telling a politician that the decision affects

a substantial share of voters. So you can see that corporate photography is aimed to improve a corporation's business.

CLIMBING THE CORPORATE PHOTOGRAPHY LADDER

No one starts out in corporate photography by getting the assignment to shoot an annual report. You have to prove yourself with lesser work to get a chance at the pearl. Company magazines and trade magazine assignments can help you build a portfolio of the kind of photographs that are used in annual reports. Editorial photography is more akin to corporate photography than to advertising illustration. So editorial photography samples can help you acquire corporate clients. A common path to success in publication photography is to start as an editorial photographer and then branch into corporate photography. Then many move on to incorporate advertising photography into their business model. Each segment is preparing the photographer for the greater challenges of the next and more demanding segment.

Chapter 6

Finding
Editorial
Clients

The editorial market consists of entities that publish information that is intended to be of value to the public, that is, information that the public has a need or right to know, and which is not intended to sell or promote a service, product, or company. The major types of editorial photography users, listed below, use millions of photographs each year.

This chapter will explain the basic nature of each of these categories of publications. It will also show how you can find specific publications in each of these categories and determine their photography needs. Now let's review what types of publications can be found in the editorial marketplace.

ATLASES

An atlas is a book that is primarily composed of maps and information about the areas mapped. Atlases can be focused

on geography, travel, historical events, astronomy, and any other subject that can be matched. Probably the most common type of atlas, and the biggest seller, is the road atlas. Undoubtedly, you have seen road atlases in bookstores' travel sections. Road atlases use photographs to illustrate the text that describes important sites along the roads or in the various areas represented in the atlas. Almost all atlases use photographs to illustrate the articles they contain to inform the reader about the geography of the areas mapped.

Atlases can be very creative and cover topics like wars past, natural resources, national parks, famous cities, and more. The one thing that most atlases have in common is that they need photographs for publication. The better news is that it is not difficult to find out what subjects they need well in advance of their need. Atlas publishers plan their books as much as two years in advance. You can contact them and ask them for a list of the publications they intend to produce and what photographs they might need for those books. When you learn of their needs, you will have time to search your files for the kind of photographs they need or, if you have the opportunity to access the sites, to shoot photographs to fulfill those publishers' needs.

TRADE BOOKS

You are reading a trade book. It has photographs in it. It happens that I am a photographer, and I have my own photographs that can be used to illustrate points I wish to make. What if I were not a photographer? Where would the photographs come from? They would come from either photographers or stock agencies.

Trade books are instructional books that focus on specific businesses and features of those businesses. They are usually published by specialized publishers or trade associations.

You can find trade book publishers in three easy ways. First, searching the Internet for "trade book publishers" will produce numerous links to a variety of sites that list trade book publishers and the types of books they publish. One such link is *www.indiandata.com/trade_books.html*.

Another way is to contact trade associations that represent members in a specific trade. Some trade associations publish their own trade books. Others are copublishers of trade books. For example, the American Society of Media Photographers (ASMP) is a copublisher of this book. Those trade associations that do not publish or copublish trade books are almost certainly going to know the names of the major publishers that publish books covering the trade of their members.

A sure way to find trade book publishers is to purchase a directory that lists such publishers. Writer's Digest Books publishes both *Writer's Market* and *Photographer's Market* annually. Both of those books list the names of publishers, what types of books they are looking for, and contact information.

Trade book publishers decide what they will publish as much as twenty-four months in advance. That means you can obtain a list of their photographic needs by contacting them and asking what titles they are preparing for future publication. Once you have those lists, you can scrutinize the lists for subjects that match your specialties. It is the match between what you photograph and what they will be publishing that will determine what the possibilities are for either receiving assignments or making sales of stock photography.

CONSUMER BOOKS

Consumer books are a good market for photographers because there are so many different types of them. With the exception of fiction, many other consumer books use photographs as

illustrations. Travel and how-to books probably use more photographs that any other types of consumer books.

The publishers of consumer books can be found by searching the Internet and through directories. But one of the best sources for information on consumer book publishers and their photographic needs is the annual *Writer's Market*, which is constantly being updated. There is also an Internet-based Writer's Market directory (*www.writersmarket.com*) that contains all the information that is listed in the book, but it is more current and regularly updated.

PICTURE BOOKS

Picture books reverse the normal approach of book publishers. They use text to supplement the photographs rather than photographs to illustrate the text. As a result, these books use substantial volumes of photography. Some of the books contain the work of one photographer only, while others use the work of multiple photographers.

The subject matter of these books is as diverse as the world itself. In a recent visit to a bookstore I took note of the subject of some picture books. There were books about architecture, horses, sailboats, cars, Alaska, New York City, football, jewelry, fabrics, wolves, zebras, and more. The obvious fact is that there is an opportunity to publish a picture book on almost any topic that could have popular appeal.

The best way to find prospective publishers of a book of your photographs is to visit a bookstore or an online book-seller to review the stock of books they carry and make a record of the publishers of those books. An online search for those publishers will help you learn all you need to know to approach those publishers.

ENCYCLOPEDIAS

Encyclopedias are books of information on multiple or single subjects. Our common experience is with the twenty-book sets of information on just about everything in the world. But encyclopedias can be much more limited. There are encyclopedias covering architecture, the human genome, life sciences, military hardware, and more. Unlike a picture book, the encyclopedia uses photographs to illustrate articles that are factual in nature. The quantity of photographs used in an encyclopedia will vary greatly depending on the subject matter.

Encyclopedias differ from consumer books in one major respect. They deal in facts, not opinions, speculation, hypotheses, propaganda, etc. The photographs they use are usually selected to support the facts. Therefore, the expository content of a photograph can often be more important to an encyclopedia publisher than its aesthetic factors.

Encyclopedia publishers are usually part of a larger group of publishers that publish educational and scholarly books. Most of these publishers are either members of the Association of American Publishers or the Association of American University Presses. The Web sites of those organizations are good places to research the publishers of encyclopedias.

TRADE MAGAZINES

Trade magazines are all about businesses. There is at least one trade magazine for every major genre of business. As a photographer, you probably have seen a few. They are distinguished from consumer magazines by the fact that they are all about the industry itself. A consumer photography

magazine might be full of photographs that illustrate the art or techniques of photography. A trade magazine is going to be full of articles and photographs that either profile people in the business, portray facilities or services, report on issues within the trade, or give business insights to improve the function of a business. A beautiful landscape photograph that might be readily accepted for publication in a consumer magazine is unlikely to be accepted by a trade photography magazine unless that photograph is to be used to illustrate an article like "Profitable Landscape Photography" or "Landscapes with Large-Format Digital Cameras."

Finding trade magazines is not difficult. One good source is the annual *Photographer's Market*, published by Writer's Digest Books. It contains information about hundreds of trade magazines and explains what kinds of photographs they publish. It is an invaluable tool. Searching the Internet for "trade magazines" is another good way to find lists. For example, Primedia Business Magazines & Media publishes dozens of trade magazines. An Internet search will turn up Primedia's Web site (*http://industryclick.com/icmagazines.asp*), where you will find links to all the trade magazines it publishes. Another search-engine find is TechExpo (*www.techexpo.com*), a directory of trade magazines, with links to many of them. And those two are just the beginning of what you can find with an Internet search for "trade magazines."

Another tried-and-true approach to prospecting for trade magazines is to simply be aware of those magazines you find in the waiting areas of business and institutions that you visit. You are almost certain to find some magazines that serve the trade of the particular business or institution you are visiting.

Not-for-profit trade associations serve most trades. Photographers' organizations include Professional Photographers of America, Advertising Photographers of America, the American Society of Media Photographers (copublisher of this book), and others. Many trade

associations publish newsletters or magazines. Once again, the Internet is a good place to look for leads to associations. A search for "trade associations" or, more specifically, "photography trade associations," will produce good results for you. For example, BusinessFinance.com's Trade Associations (*www.businessfinance.com/trade-associations.htm*) comes up on such a search. Its Web site provides links to hundreds of trade associations.

Another way to find trade associations is through the association to which many of their staff members belong. The American Society of Association Executives publishes a directory of its 55,000 members. That directory includes contact information for each member, which can lead you to the member's employer.

The fact is that trade magazines are probably the simplest of any category of publication to research. All it takes is time and dedicated effort.

CONSUMER MAGAZINES

Have you been to the magazine rack of a large bookstore lately? If you have, you noticed that the magazines available for purchase take up a substantial amount of shelf space. Believe it or not, any one of those bookstores is probably displaying less than 10 percent of the total number of consumer magazines that are available. I recently visited a large bookstore near my home. According to the manager, there were more than seven hundred magazine titles for sale in the store, about 10 percent of all consumer magazines. With seven thousand magazines as a market niche, any photographer ought to be able to find a few that will publish his photographs.

Unlike trade magazines, lists of consumer magazines are more difficult to locate. The annual *Writer's Market* and *Photographer's Market* publish lists of consumer magazines

with specifications for the type of photographs needed. You have now seen the names of those two directories repeated over and over in this chapter. You really ought to have both books if you are seriously interested in licensing photographs for editorial uses.

Once again, an Internet search will turn up good leads to consumer magazines. But this time, search for "consumer magazine publishers." For example, such a search will turn up the Yahoo! Directory of magazine publishers (*http://dir.yahoo. com/Business_and_Economy/Business_to_Business/News_and_ Media/Magazines/ Publishers*). In that list, you will find links to many magazine publishers' Web sites. One of those publishers is Rodale, which publishes consumer magazines. You can follow the links from Yahoo! to the particular publishers, and then to any of the magazines they publish.

You can also prospect the old-fashioned way. Every time you see, read, or get hold of a magazine, note the title, publisher, and Web site of either the publisher or the magazine. Those Web sites will provide you with the information you need to determine whether you are looking at a market for your photographs. Here's an example. I did an Internet search for "Time Inc.," the publisher of *Time* magazine. One return was listed as "Time Inc. Portal." Following that link (*www. pathfinder.com/pathfinder/index.html*) took me to a listing of and links to the eighteen consumer magazines published by Time Inc. Following the links to those eighteen magazines will allow you to determine which, if any, of the magazines is a prospective user of your photography.

CORPORATE MAGAZINES

Corporate magazines are those published by corporations. Remember that corporations include for-profit and not-for-profit entities. Avnet, Inc., is a large company that

makes electronic components. It employs more than nine thousand people worldwide. It publishes an employee magazine titled *Avnet Global Perspective*. Maryknoll is a missionary organization. It publishes *Maryknoll* magazine. Both *Avnet Global Perspective* and *Maryknoll* magazine are corporate magazines.

The corporate magazine market is declining as the Internet becomes the preferred means of communicating an organization's message to its employees and the public. Researching corporate magazines is not easy because many of them have a limited circulation, such as just to employees or contributors. One way to find them is by keeping your eyes peeled in your travels. The next time you fly with a commercial airline, you will probably find its magazine in the pocket of the seatback in front of you. That magazine is a good example of a corporate/company magazine. Another way is to look at corporate Web sites to see whether they publish a magazine. Of course, you can do that as part of your research on the corporate market.

MULTIMEDIA PRODUCTS

"Multimedia" includes informational products like CD-ROMs, DVDs, films, and videos. These are electronic media of both the digital and analog types. They are used to present text, graphics, video, animation, and sound in an integrated way. The products might be educational or documentary in nature. The range of applications is enormous. The military services distribute them to increase recruitment. Educational information producers publish them for classroom use. Multimedia producers now publish much of the information that was previously confined to paper books as multimedia programs. Multimedia products offer a ready market to photographers.

The key to being published in multimedia products is to find the producers of the products and then find out what topics they are in need of photographs for. Finding the producers takes some effort. Producers can be single-person operations or employ hundreds of people. You can use the Internet for leads by searching for "multimedia producers," or do the same search in Yahoo! Directories. The searches will produce many links, and you will have to sift through them to find leads. Keep in mind that many multimedia producers' associations are local rather than national. When you find them in your search results, contact them to see if you can get a list of their members.

There are two other ways to find multimedia producers. One is the Yellow Pages. Look under "multimedia services." In larger metropolitan areas you will usually find a number of listings under that heading. But, since authoring software for multimedia products has become very affordable and relatively easy to use, a variety of professionals in other disciplines, like designers, illustrators, and photographers, have begun to produce multimedia products. So you won't find all the producers that way. What you should do to find the producers is go to the higher-volume buyers and users of multimedia. You can ask them for the names of the producers of the products they buy. School, public, and corporate librarians and audiovisual department heads are the people most likely to have information that can help you.

WEB SITES

Editorial Web sites are those sites or sections of sites that provide information that the public has a need or right to know. CNN's site (*www.cnn.com*) and the BBC's site (*http://news.bbc.co.uk/*) are two examples. They are primarily aimed

at informing the public. The fact that they might draw viewers to the television outlets that each owns is incidental to the main purpose of the sites. Another example is the not-for-profit mission previously mentioned, Maryknoll. Its Web site (*http://home.maryknoll.org*) takes great pains to introduce you to the human condition in remote parts of the world. The fact that you can make a contribution to Maryknoll via the site is incidental to its main purpose to inform.

Finding informational Web sites is not rocket science. Let's say that you just photographed a U.S. Army Stryker unit. If you search the Internet for "U.S. Army Stryker," you will find listings of sites that use photographs of Stryker vehicles and the personnel that man them. If you photograph model railroads, you can find numerous sites that use that kind of subject matter. The only thing you need is patience. Internet searching takes time. But that time can pay off in a big way when you have the right subject matter, and you find that there are many Web sites using that kind of material.

ACADEMIC BOOKS AND PAPERS

Academic books and papers are usually written by academics, like professors, associate professors, and Ph.D. and master's degree candidates. They can be written on almost any topic imaginable, because the writers are studying and teaching a huge range of topics. While many of these books and papers are text only, some of those have cover photographs. Others use photographs to illustrate the text. Often, the writer will have his own photographs to use as illustrations. In other cases, the writer or publisher will have to acquire illustrations. If you happen to photograph the topic being written about, you might have sales waiting for you.

A friend of mine, a high school teacher who was an excellent photographer, used to spend his summers in Central and South America on archeological digs. In the process, he built a substantial library of photographs of pre-Columbian art. He sent that information to academic publishers and profited from it over the next few decades when they needed photographs to illustrate academic writings on the topic.

Academic books and papers are published by university presses, that is, publishing operations that are owned by universities. The easiest way to find those publishers is through an Internet search for "university press." You will find many leads through such a search.

NEWSPAPERS

There is no need for me to explain what a newspaper is. I also consider newsletters to be newspapers. And it is obvious to any newspaper or newsletter reader that photographs can play an important part. Newspapers use all kinds of photographs, but the catch is that most of those photographs have to be timely, that is, taken recently. Photographs of a football game or concert are not going to be run in a newspaper three weeks after the event unless the newspaper is a monthly or is running a story on a past event.

Most newspapers get their photographs by assigning either staff or freelance photographers to cover scheduled events and breaking news. Freelance newspaper photographers, called "stringers," are usually part of a group of photographers used routinely by the newspaper. That group is often referred to as a "stable." So, to get work, you have to get into the stable. To do that, you have to find the newspapers that you might shoot for.

Once again, the Internet is a great way to find newspapers. One directory is located at *www.journalismnet. com/papers*, and another can be found at *www.abyznews links.com*. You can find listings at these two sites for newspapers based on frequency of publication, interests, country, region, and city. You will probably find all of your local newspapers at one or both of those sites.

Keep in mind that newspapers often have to cover events that are not in their own geographic area. Maybe the hometown sports team or orchestra is playing in another city. That can mean an assignment for the photographer who is ambitious enough to get onto the list of available photographers that the newspaper is likely to have.

BROADCAST AND CABLE TV NEWS

No definition of this market is necessary. If you have a TV, you have already been exposed to the broadcast and cable TV news market. While most TV news stations cover the news with video crews, there are the occasions when a video crew either doesn't get to the scene on time or doesn't get there at all. In that event, if the news story is important and you have photographs that tell the story, it is quite possible that you will be able to license the use of those photographs to a TV news program. Of course, those opportunities may never present themselves to you. But if they do, you should keep in mind that you have a prospective sale.

How do you find the stations? Turn on the TV between 5:00 P.M. and 6:30 P.M. and just keep roaming the stations until you find them all. Then do an Internet search using the each station's call letters to get to the station's Web site for contact information. But do that search before you need it. If you get great photographs of breaking news, you don't want to lose the sale because you have to take the time to

find out contact information for a station. Chances are, if you don't have that contact information with you, some other photographer with a radio scanner is going to get to the story scene quickly and then get to the station quickly.

EDITORIAL MARKET DIRECTORIES

In a world where information is valuable, there will always be some person or company that will accumulate information and sell it. That is true for the editorial photography market. *Writer's Market* and *Photographer's Market* are directories that are for sale in bookstores. But there are directories that are not available in bookstores, and there are online directories. The very best ones are usually very expensive to buy as books or to subscribe to online. However, some are free.

An Internet search for "directories of publishers" will provide you with many links to very comprehensive lists of publishers, which in turn have links to the publishers' Web sites. But other links will take you to subscription Web sites where you pay a fee to access their lists and download information. Those sites are the kind used by communications people to find the most current and exact information available about publishers. Subscriptions are usually very expensive. However, you should look on those Web sites for information about a printed directory. If the service provider has a directory in print, chances are you can find a copy in the business reference section of major metropolitan libraries or in university libraries. Using downtime to visit those libraries will give you the opportunity to cull the directories and copy information from them. Take either a lot of dimes for the photocopier or a handheld text scanner. Otherwise, you'll be doing a lot of handwriting. Two directory publishers are Bowker (*www.bowker.co.uk/products/print.htm*) and Gebbie Press (*www.gebbieinc.com*). Both offer a variety of

directories of publications. Both are very expensive, and both companies' directories can often be found in libraries.

BREAKING INTO EDITORIAL PHOTOGRAPHY

Editorial photography is the easiest market segment for a photographer to break into. The reason for this is because the editorial market has several levels of quality. Let's look at some of the different applications in editorial photography and examine the levels.

Market Tiers

The diverse range of publications coincides with the levels of experience of photographers. The beauty of a hierarchical market is that the qualifications to work for a publisher on the bottom tier of the market are lower than those required to work for a publisher on the highest market tier. That, in turn, means that the inexperienced photographer can start at the bottom and work his way up to the top. Using newspapers as an example, we find multiple-edition dailies, single-edition dailies, semiweeklies, weeklies, and, although rare, biweeklies and monthlies. We'll ignore the latter two because they are deviations from the norm. Newspapers can be international, national, regional, or local. If you took the publication frequency and geographic publication areas in order of frequency and size of geographic territory, you would see a hierarchy develop, with international multiple-edition newspapers on top and local weekly newspapers on the bottom.

You can be assured that many photographers who are employed by national daily newspapers started out shooting for a local weekly newspaper. The nature of newspaper

Figure 3

TIER	MAGAZINE	CIRCULATION	COVER PHOTO FEE
$$$$	Southwest Airlines Spirit	350,000	$1,200
$$$	Careers and Colleges	100,000	$ 800
$$	Junior Scholastic	589,000	$ 350
$	Fishing & Hunting News	133,000	$ 50

photography is that most general-interest newspapers, regardless of size, have the same kind of content needs. Breaking news, sports, society, and features are common to them all. If you can satisfy the needs of a local weekly for a year or two, you can probably satisfy the needs of a small daily magazine. Do that successfully for a year or two and you are probably ready to work on a larger daily newspaper, and so on all the way to the top.

Like newspapers, consumer and trade magazines also have tiers. The chart in figure 3 shows four different magazines and their rates. It is an example of the tier structure.

You might look at the above chart and wonder why it does not contain titles like *Time* and *National Geographic*. There are two reasons that it does not: First, these are not the mainstream titles of the editorial world; they are elite. If you hope to earn your living shooting only for elite titles, you will probably soon learn that it is nearly impossible to do unless you get a job on staff or on contract or become one of their regular freelancers, and those are very few and far between. Second, the elite magazines do not usually pay elite rates. The fact is, the magazines that have the biggest names often pay average fees because so many photographers want to be published in them; there is an unending supply of people who will accept less for the prestige of being in those magazines.

Where to Start

If you are just starting to publish your photography and you have not spent time as a photographer's assistant learning how the business works, you should give serious consideration to starting as an editorial photographer. There are so many publications in which you can be published. Most of them are tiered, so the field provides opportunities for the beginner, for the highly experienced photographer, and for everybody in between.

You want to be sure to start your life as a publication photographer in a tier of work that you can compete in. If you are a beginner, don't try for the *New York Times* or *Time* magazine. Go for your local newspaper and local or regional magazines. Look for trade magazine publishers in your area who publish to regional businesses. Save the national publications until you have developed some credentials serving the smaller markets.

There are many millions of editorial photographs published every year. If you can meet the aesthetic and technical needs of those who publish those photographs, there is no reason why your photographs can't be published too.

How to Start

How you get started in editorial photography depends on whether you are adding it as a segment to your existing photography business or starting a new business. If you are already successfully producing photography for other segments of the business, all you need to do is create an editorial photography portfolio, find prospects, promote your services to them, and close deals to do assignments or sell stock photographs. If that sounds too easy, you are right. It isn't easy. It just sounds easy. That is not to say it is difficult either. It isn't. It is simply a routine of doing business as your daily grind. Those who fail in business usually do so because they neglect those

daily-grind activities. They neglect them because they are not creative pursuits. Photographers want to make photographs, not sales calls. But if you want to be published, you have to sell yourself and your work to prospective publishers.

Earlier on in this chapter I suggested how you could find prospective publications that might accept your photographs. Once you locate those prospects, you can easily determine who the photo editor or art director is, and then make contact. Start by looking at the magazine's masthead or its list of editors at its Web site. If there is a photo editor, start with him. Solicit the art director only if there is no photo editor or comparable position. If you can find no evidence of either position, call the publisher and ask who hires assignment photographers and/or buys stock photography. Once you have the names you need, you are ready to promote yourself to those people.

TYPES OF PHOTOGRAPHY

Photography is divided into two types: *reportage* and *illustration*. Reportage is the factual presentation of what is unfolding before you without any direction on your part. Illustration involves directing the subject you are dealing with. The word that separates the two types is "direction," that is, the guidance of the subject. In reportage, you control only your actions. With illustration, you control the subject's actions to one extent or another. If you are to succeed in editorial photography, you have to be comfortable with both types. One day you might be assigned to cover a football game to get action shots of the game and portraits of the coach. The game will be reportage. You might even get a good candid portrait of the coach as part of that reportage, but you will be expected to get some kind of environment-related portrait of the coach. That portrait might look candid even if it is an illustration.

Figure 4

Remember, an illustration only means you took control of the subject to get the photo you wanted.

Two examples of how you cannot always tell the difference between reportage and illustration are portrayed in figures 4 and 5. Figure 4 was taken as part of an assignment to photograph a stage play and its director. The photograph depicts the director giving instructions as he records sound effects being made by the actors. Figure 5 was taken as part of a photo story on a scientist for a science annual published by an encyclopedia publisher.

Can you tell which photograph just unfolded as the action played out and which one was posed, that is, which is an illustration? The answer is that the photograph of the stage director is reportage, and the photograph of the scientist is illustration.

You want to be certain that your prospect knows that you can do candid-looking illustrations when called upon to do so. Budgets for editorial photography are usually low, and so the amount of time allowed to do any given job is often shorter than the photographer would like. In such cases,

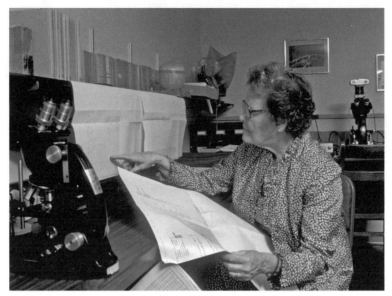

Figure 5

you often have to take the initiative and get the kind of photographs the photo editor wants by directing your subject. If the photo editor knows you can do that, you have a much better chance of being selected for assignments.

ASSIGNMENT SERVICES AND AGENCIES

If you are not inclined to handle the business aspects of the editorial photography business, you have alternative approaches to getting published and making money in the process. Let's face the fact that not everyone is equipped psychologically and educationally to run a classic business. For those who find themselves in that situation, there are alternatives.

The most obvious alternative is to be a staff photographer for a publication. But that is unlikely to happen unless you have spent some years developing your credentials as a publication photographer. With the exception of

newspapers, most publications do not have staff photographers. Those that do have usually selected that staff from a group of highly qualified and successful freelance photographers. So you have to look at the other alternatives: assignment agencies and wire services.

Assignment Agencies

Many decades ago, some smart, business-minded people recognized that fact that many good photographers wanted to make photographs without dealing with the chores that running a business entails. What those entrepreneurs did was create agency businesses that took care of those business operations for the photographer for a fee. One of the more famous agencies of this sort is Black Star in New York City. It represents photographers from around the world and provides clients with assignment photography through the services of freelance photographers who have the responsibility to shoot and edit assignments procured for them by Black Star. It also keeps many of those assignment photographs on hand to be used to fulfill stock photography requests. The beauty of the arrangement is that the photographer only has to be a photographer and not a businessperson. The downside is that you will be dependent on the agent for your business. Lose the agent and you could be out of business. Of course, you can have such an agent and back yourself up by having your own direct clients too.

The world's two largest stock agencies, Corbis and Getty Images, have grown to immense size by the acquisition of many small and previously independently owned agencies. They have also acquired many of the assignment agencies that were once independently owned. But these giants do have assignment agency operations that you might consider if you are planning to take the agency path.

Wire Services

An opportunity for the newspaper-oriented photographer who wants to avoid the business chores is the wire services. The two largest wire services are The Associated Press, often referred to as AP, and Reuters. Both services have staff and freelance photo-graphers around the world. The staff photographers are usually located in large metropolitan centers where news is being made daily. The wire services use freelance photographers all over the world. They often use freelancers to supplement staff in places where the workload fluctuates and staff cannot handle it all. They also use freelancers in places where they have no staff and news breaks out.

Freelance photographers who work for wire services in metropolitan areas can often be kept so busy that they do not have time to do other work. There is a lot of news to be covered on a daily basis. If you are kept that busy, it is possible that you will be considered for a staff position when one becomes available. It is also possible that you will be considered for a freelance contract that ensures you a good flow of assignments.

If you have the goal of getting a staff newspaper position or breaking into the newsmagazine editorial market, wire service assignments are a good place to get the experience and the publication credits to prove yourself.

EDITORIAL STOCK PHOTOGRAPHY

Editorial stock photography differs from promotional stock photography in one significant way other than the market segment served. Editorial stock does not require model releases. Almost all stock agencies and photographers who license stock serve both editorial and promotional photography

users. Some agencies and photographers limit themselves to one or the other. Some photographers sell their own stock. Others have contracts with stock agencies. Some do both. Usually, the photographers who do both are focused on stock shooting more than assignments, and the photographers who use agencies only are frequently heavy assignment shooters who don't have the time sell stock, or they are stock shooters who don't want to be concerned about the daily grind of the stock business.

In addition to providing many opportunities for the full-time professional photographer, stock photography agencies present a great opportunity for the semiprofessional photographer, that is, the amateur photographer who is making some part-time money through photography. The part-time shooter has little to no time to operate a business. He needs to find way to get his photographs into the marketplace by other means. The best way is through a stock photography agency. Agencies can be located in two easy places. One is *Photographer's Market*, which has been mentioned previously as a good resource. The other is through the Web site of the Picture Archive Council of America (PACA), a trade association of stock agencies with more than one hundred of the top stock agencies as members. Its Web site, *www.pacaoffice.org*, is a great starting point for the photographer in search of an agency.

If you are going to become allied with a stock agency, you ought to also look into joining Stock Artists Alliance (SAA). It is a trade association of stock photographers. SAA offers lots of guidance for the photographer who is getting into stock, especially those who are going to contract with a stock agency. Those contracts can be very complex, and you ought to be sure that you understand the ramifications of entering into such agreements. SAA has a Web site at *www.stockartistsalliance.org*. Be sure to visit it before getting into a contractual stock photography relationship with SAA.

SUCCESSFUL EDITORIAL PHOTOGRAPHY

"Success comes to those who dare" is a comment often quoted. Of course, daring in itself is not a good path to success. Anyone can dare to try to break into editorial photography. Many have dared and many have failed. Those who succeeded did so because they were smart about how they did it. First, they understood the composition of the market. Then they analyzed specific applications in the market to see where they had a fit with the market. Then they promoted themselves or found agents to do it. Finally, they were on the road to achieve success. It was more than daring behavior. You can be on that path to success as a published editorial photographer. Just understand this chapter and the rest of this book, and act accordingly.

Chapter 7

Finding
Merchandise
Segment Clients

The merchandise segment of the market is a relatively new and emerging publication opportunity for photographers. Applications like greeting cards, calendars, framed pictures, and posters are examples of merchandise that uses photographs. But other products like T-shirts, plates, and bank checks are also merchandise. This market segment is the smallest of all. The publisher base is hard to locate, but once you have the prospects identified, the opportunity to make sales is excellent.

A wonderful aspect of this market is the fact that serendipity plays an important role. More often than not, the photographs that are prime candidates for this market are those that you stumble across. In the examples that follow, I'll explain how serendipity and good marketing sense can get you published.

GREETING CARDS

The largest part of the merchandise segment is the greeting card business. Every year, more and more greeting cards using photographs instead of illustrations hit the shelves of retailers. The subject matter of those cards run the gamut, and can include pets, landscapes, flowers, children, cars, and almost any other subject that is appealing to the eye. The topics for cards are almost endless.

Two companies, American Greetings and Hallmark, control about 80 percent of the entire greeting card market. Because of their market share, they have an abundance of stock agencies and photographers soliciting their business. That does not mean you should not try to get their business. It means that you will have a harder time making sales to these companies than to others with a smaller market share. But when you have the right photograph for a card's theme or a strong enough photograph that it evokes its own theme, you have a good chance of selling your image for use on a card produced by one of the giants.

The 20 percent of the marketplace that is divided up among the other greeting card publishers is still worth pursuing. You can find some of those publishers in *Photographer's Market*. There are three other ways to find prospects in this market segment. One way is to subscribe to *Greetings etc.*, a trade publication that serves the greeting card industry. It contains news on trends, new products, and trade shows where greeting card publishers can be found hawking their wares to retailers. You can learn more about that publication at *www.edgellcommunications.com*. Another way is to attend the biggest trade show of the greeting card industry, which is held annually in New York City. Details about the show are available at *www.national stationeryshow.com*. The third way

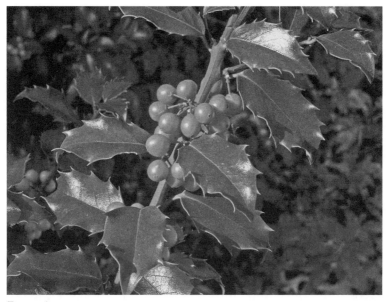

Figure 6

to find prospects may be the easiest. Visit greeting card retail outlets and look at the cards that use photographs. Copy the publishers' names and then look them up on the Internet.

An example of a seasonal greeting card photograph is shown in figure 6. Originally published in color, the plant section is from a holly bush that was in bloom, with its red berries. Obviously, it fits a Christmas theme quite well.

I took the photograph while I was on a walk. The colors of the green-and-red plant caught my eye. Then the plant caught my marketing instinct. The bush was a good and unblemished specimen. It made me think of Christmas, which made me think it would look nice on a Christmas card. I sent copies of it off to several greeting-card publishers, and it was accepted and published by one of them.

POSTERS

You have undoubtedly noticed the widespread use of photographs on posters. The posters range from the inspirational to the sensational. A picture of a soaring eagle or a singing celebrity are both examples of the kinds of images that you will find on posters.

The most important element of a photograph that is required for a poster is called *poster effect*, which means that the photograph has a strong graphical composition and has only one subject, which is not competing for attention with other elements in the composition. That sounds easy, but in fact it isn't. All too often, we do not have the control we need to make a photograph with poster effect. Lighting, background and foreground, unwanted people, other things often dilute the poster effect of our photographs. But sometimes we are fortunate enough to be able to overcome those obstacles. Here's an example.

In figure 7, you see a photograph of a walkway located in Blenheim Palace in England. I visited the palace, the birthplace of Winston Churchill, as a tourist. Of course, I refused the opportunity to take the tour of the palace, and struck out on my own. As I walked the grounds, I came upon a long walkway with one side made up of a series of arches. As you look at the photograph in figure 7, understand that I entered the walkway from the far end in the photograph. I walked through it on my way to another part of the palace. When I came to the end of the walkway, I did something I advise every photographer to do. Look back! As I did, I saw the length of the walkway as depth and the arches as repetition. The arch used to frame it wasn't noticed until I moved a few feet to see what a different angle might offer. I saw an interesting composition, but the light was terrible. It was an overcast day and the lighting was very flat, even, and uninteresting. Knowing the

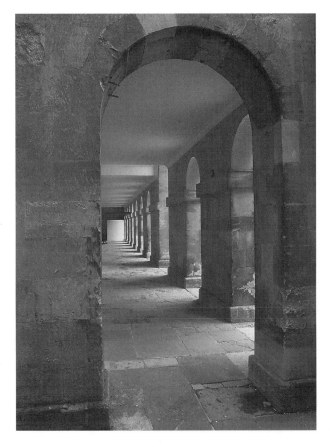

Figure 7

weather and therefore the sunlight can change rapidly during the English summer, I stayed at the palace for another hour. Luckily, the sun peeked out for a while just as it was in a position to obliquely light the walkway. Rushing back to the scene, I took the photograph you see. Before I could make another frame of the same subject, the light changed back to the drabness I originally saw.

I had one photograph, but I knew it had potential. Since I had used a digital camera, I could review the shot immediately. I saw the interesting interplay of shapes and light. I saw the small square of light at the end, and it reminded me of the expression "light at the end of the

tunnel." Within six months, the photograph was published on a poster. Opportunity often occurs when you least expect it. Vigilance and patience pay off.

Poster publishers can be found among the greeting card publishers in *Photographer's Market*, through an Internet search for "poster publishers," and by the tried-and-true method of visiting poster shops and writing down the publishers' names to research later on the Internet.

CALENDARS

Like greeting cards, calendars abound, and many of them use photographs. Calendars are sold in a variety of stores, with bookstores being a huge distribution channel. Of course, the retail calendar market is a seasonal market, lasting from about September through January. Calendar publishers plan the themes for their products one to two years in advance of publication. So don't expect to see your photographs on an actual calendar for some time after you make a sale.

Calendar publishers look for photographs based on themes that they conceive of or that are proposed to them. If they conceive of a theme, they might use one or more sources for the photographs on any given calendar. If they accept a theme proposed to them, they will usually want the party who made the proposal to supply all the photographs for the calendar.

Calendars are daily, weekly, and monthly in format. Daily and weekly calendars don't use many photographs because they are usually just utilitarian in nature, while monthly calendars are both utilitarian and decorative. The big market for photographers is the monthly calendar market. Monthly calendars, like greeting cards, cover as many topics as a person can imagine. Flowers, animals,

Figure 8

cars, landscapes, and architecture are common examples. But more novel themes are also published.

In figure 8, you can see one of a series of photographs that I am about to submit for publication on a calendar. I have been developing a series of photographs of people on benches for a picture book that I'd like to have published. As I was researching picture book publishers on the Internet, I discovered that some of them are also monthly calendar publishers. I decided to put together a dummy calendar of my photographs of people on benches and offer it to one of the publishers. For those who are unfamiliar with the term, a *dummy* is simply a mock-up of a proposed publication. I'll make it myself on my computer. About the time this book goes on sale, I hope to have that calendar on sale too.

When it comes to finding calendar publishers, I do not recommend a broad Internet search. There are many calendar publishers, but most of them are publishing utilitarian calendars or specialty advertising calendars, like the kind

you insurance agent might give you. When those publishers use photographs, they look for the most generic and inexpensive images they can find. They simply are not good prospects.

To find good prospects, you ought to go to a bookstore or other retail outlet that sells decorative monthly calendars. Note the publishers' names and study the calendars on sale to see the kinds of photographs they used. Then do your research on the companies on the Internet.

FRAMED PICTURES

A new application in the merchandise segment seems to be slowly emerging. Picture frame manufacturers are finally beginning to use reproductions of photographs to enhance the sales appeal of their frames. Some are even using high enough quality art that the frame picture can be used as display art, or the reproduction can be tossed away to use the frame for the purchaser's own art.

Finding the frame manufacturers that are prospects for your photography requires visiting stores that sell frames with art already installed in them. I have found these frames in department stores, artists' supply stores, poster shops, and household goods stores. The manufacturers are usually identified on a label on the frame's packaging. If the manufacturer is not identified, you can usually find out its name from the store manager.

Figure 9 is a photograph that I made many years ago of my daughter, now grown and married. As I write this book, it has been sold to a manufacturer of fine picture frames to be used as an insert in one of the frames it offers through retail stores. Obviously, the photograph is intended to promote the sale of the frame and not to be used as display art.

Figure 9

MERCHANDISE IN GENERAL

The use of photographs on a variety of other merchandise seems to be growing. I have seen bank checks, matchbooks, notebooks, and even paper bags that bear photographs. It seems like photography is finding its way onto more and more products as a decorative aspect. It behooves the photographer interested in this market segment to watch for developments. While the merchandise segment is still dominated by a few

93

applications, opportunities are not only increasing in those applications' areas, but are also growing into new applications. Finding an emerging market for which your photographs are suitable is a good way to build sales through new publication. The market research for all the applications can be done easily by identifying manufacturers and searching their Web sites, which can be found by an Internet search. This is a market you ought not to ignore.

Chapter 8

Marketing
Your
Photography

The objective of your business is to make money by licensing your photographs. As a photographer, you have something to sell. Now all you have to do is sell it. The problem is that unless you approach the sale of your photography correctly, you will not sell very much.

Marketing is a combination of three processes: research, promotion, and sales. Many photographers are very heavy on the promotion process and very light on the research and sales processes. That is because promotion is the easiest of the three tasks. Promotional saturation will lead to sales, but promotion alone will never develop a reliable and consistent flow of paid publication. There is a reason that big companies conduct market research and then design their promotions and advertising to exploit their research. They know, and you know, that it is easier to sell something to a person who needs or wants the specific product or service you are selling. Photographers are not just

selling photography. They are selling creativity production capability, and specialties that combine in a final product—the photographs that a prospect needs or wants. The important words for you to keep in mind are "the photographs that a prospect needs or wants." Market research is how you determine what those photographs are. Promotion is how you tell the prospect you have what it wants. Selling is the process of turning the prospect into a client by getting it to buy from you. The research/promotion/sales trinity is the most important function in your business because without them, you have no sales, and that means you have no business.

MARKET RESEARCH

The purpose of market research is to determine who is buying what and how much they are willing to pay for it. The marketplace is huge because there are millions of photography users. You have to pinpoint those to whom you are likely to be able to sell your services. These will be your prospective clients. Some of these prospects will eventually become your clients. Before you do any selling, you have to do your prospecting.

In the previous chapters dedicated to the specific market segments, you learned about the different publishing applications in each market segment. You also learned how you might find and research the prospective clients who publish those applications. The sources of prospect information for each segment vary, but the information-gathering technique doesn't. You have to search, find, and analyze the results of your search to determine what kinds of photographs an advertising firm, corporation, or publisher uses and who buys the

photography for that entity. That process is called _qualifying prospects._

QUALIFYING PROSPECTS

Too few sources of prospects provide the qualifying details that you need. By "qualifying" I mean learning the who, what, when, where, why, and how of the company's photography buying habits. So, in many cases, you have to do that research. Unless you want to spend your life in the library to get maybe a 10 percent success rate, you had better turn to the Internet. Photographers thought that the Web was going to provide a bonanza for them in image sales. Well, it hasn't, because most Web site producers go for low-budget work, and royalty-free photography is usually more than adequate for their needs. It is time to wake up and smell the coffee. The Web does pay off in increasing sales—if the photographer uses it correctly. When it comes to market research, the Web is unbeatable for the solo practitioner (which most photographers are). You can get more information about a company on the Web in ten minutes than you can get in ten hours any other way.

I use Google for market research. Its search engine is more intuitive than any others I have tried. It even corrects mistakes in your entry typing, and it asks you if you meant what you wrote, suggesting what it thinks you want to find. Pick an advertising agency for which you have a name and location. Search under those terms in Google. Your query might look like this: Funhouse Advertising + New York. It is important to learn how to use qualifiers to limit search results. Google and other search engines have online advice on how to use them. If Funhouse has a

Web site, Google will find it. But it will find other things too. I have done this over and over again in my recent market research efforts, and here is the kind of information I am getting by doing so:

Good Information

From the prospect's Web site, I can learn the proper name, address, and phone number of the agency. Many have the names of clients, so you know whether you are shooting the kinds of subject matter those advertisers use. There are samples of ads they have produced so you can see the trends in the agency's work. Some sites are even kind enough to provide the names of art directors and art buyers in the agency, saving a lot of phone calls to find out whom you want to contact. I can also judge the stature of the agency by the quality of its Web site.

From other Web sites listed in the search, I can find articles about the agency that can help me qualify the prospect. Press releases from companies that have recently hired the agency also show up. If a company hires a new agency that will be taking over future PR work, it can give me a jump on my sales effort. This means that I can get a portfolio together to show work that fits the advertiser's needs. For example, if I find that Bigfoot Shoes is going with Funhouse Advertising next month, I can promote myself to Funhouse with a great display of shoe-related photographs.

QUALITY, NOT QUANTITY

Remember this: It is the quality of your research that will pay off when it comes time to promote yourself efficiently and affordably. If you do the homework, you will get the grade

you need in the test, that is, the test of any business—making sales. Many photographers think that they can avoid market research by purchasing mailing labels of photography buyers to whom they will mail some promotional material. The photographer might pay $250 to $500 for two thousand labels, depending on the quality of the list. They spend two to four thousand dollars on material and postage to send some promo piece to each name on the list. In the end, they have spent thousands of dollars to send their promotion to a prospect that they know nothing about. If your beautiful poster of a shoe gets to the spaghetti art director, it is likely to go into the trash can along with the other dozen pieces that the art director received that day. Sure, he keeps one, and he hangs it on his wall. Which one? The one that interests the art director personally because it is exceptional art or something that the art director is really interested in. But if you only know the art director's name, how can you know what his interests might be? You have to qualify your prospects if you want your promotions to pay off.

PRODUCTIVE PROMOTION

Imagine that you are an art director working on several campaigns in different stages. For the past few weeks, you have been concentrating on how to make motorcycles, surfboards, and sunglasses look so good that people will want to buy them. Your weeks have been full of long hours and high pressure as you conceptualize, design, select photographers, and supervise photo shoots while keeping up with your mail, phone calls, and e-mail. You are feeling exactly what you are—harried.

In this morning's mail you received fourteen postcard promos from photographers, one stock catalog, six stock agency promos, two posters, a tube with a filmstrip in it,

two CD-ROM promos, and several invoices. And you have to interview three photographers to prepare them to bid on approaching jobs, look over the photos from yesterday's shoot and fit them to layouts, and come up with a few sketches for an account exec who is putting together a pitch for a prospective client.

If you were this person, how much time do you think you would spend mulling over the promotional materials in today's mail? Not much. Unless one of the promotional mailings jumps up and bites you, you probably will toss the pile of them into the circular file. My point is simply this: Busy people don't stop to look at the ordinary. Even very good photography is ordinary to an art director. If you want to get the art director's attention, you will have to do something extraordinary. This also applies to editors and communications directors. Fortunately, there are ways to do this.

QUALITY VERSUS QUANTITY

The term "information overload" was coined in the past decade because we are all swamped with more to see, read, know, and use than we can manage in our minds. A decade ago, I would have advised you to send a repetitive stream of communication to a prospect so that your name would be associated with photography in his mind when he needed to hire a photographer. Today, loading up a person with more and more information is akin to harassment. To be retained as a good potential source of supply, you have to send the prospect something he or she can immediately relate to. That means it has to have direct, not indirect, meaning. A fine picture of a pony displayed on a promotional piece is not going to have an immediate effect on an art director who is

working on a motorcycle or surfboard campaign. What would have an immediate effect is a picture of a motorcycle or surfboard, because those are directly on his mind right then.

TARGETED PROMOTION

You have to know what your prospect is doing. Sometimes it is easy to figure out. For example, we know what kind of pictures the editor of *Baseball News* is looking for. We know that the communications director of a machine manufacturing company wants to see machinery of a size and type comparable to that which the company makes. Art directors are a different story, unless they or their agencies are very specialized. Art directors have diversified and changing photo needs, so it is harder to know how to have that direct effect. But it is possible. I am going to use an advertising example below, but the process described can be easily adapted to prospects in the other market segments. Remember, I am describing a process, not an exact model to be followed.

Depending on how much research you have done in your marketing effort and how deep you have dug for information while prospecting, you can find out both the past accounts and the current accounts an art director is working on. Armed with that information, you can scour your files for images of the same subject matter, or maybe even create it. If you don't have it and can't create it, you might have images that are similar in concept. I'd bet an art director could make the association between the conceptual similarities of a snowmobile and a motorcycle. Once you have a match or a close match, you are on the way to reaching that art director in a memorable way.

USE YOUR CRAFT

In order to catch an art director's attention, make a beautiful but small print. Mount it with your contact information on the back. Put a letter with it that is written something like this:

Dear Ms. Buyer:

Recently I discovered that you art-directed last year's Maniac Motorcycle campaign. It was an impressive bit of work. I find myself wishing I had done it.

 The print that I have enclosed is from my work on the Downy Snowmobile campaign of two years ago. I think snowmobiles and motorcycles create the same sense of freedom in their rides. I don't know whether you will be awarded the Maniac campaign again, but if you are, I hope that you will allow me to offer my services. Of course, I'd be happy to work with you on any other projects.

 My contact information is on the back of the print and my card is enclosed. My Web site, *www.happyshooter.com*, has a good representation of my work, if you have the time to look at it. Speaking of time, I don't want to waste yours. Thank you for keeping me in mind.

Sincerely,

(your name)

The letter takes about thirty seconds to read. Your name is on the envelope and the letterhead. It is likely in the URL of your Web site. It is on the signature line of the letter and on the back of the print. This art director

read your name five times in less than a minute. It could be that she'll remember it when she hears it again, or when you make a follow-up call to see if you can get an appointment to show your work. Moreover, she sees that you have done some homework. Art directors like thorough photographers. You have shown her that you understand conceptual relationships with your comparison of riders of motorcycles and riders of snowmobiles. Her work is translating a concept into an imagined reality, and you speak her language. Finally, it calls up the past for her. If she likes your photograph better than that used in last year's campaign, she is even more likely to remember you. You have made a bigger impression on her than a photographer who sends her a 24" × 36" poster featuring a photograph of shoes would make.

The next step is to find out what her current or approaching campaigns will be. Repeat the process above using photography with subject matter that is identical or similar to what she will be working on. She will not only get to know your name better, but she will also see that you are really serious about getting the business and working hard at it. Hard work impresses people, reinforcing a message convinces people, and treating people as individuals rather than as one of the crowd is likely to get you treated the same way. If it sounds like hard and time-consuming work, it is. But you can do it while you are sitting around waiting for the phone to ring, and then you will have a reason to make the prospect's phone ring.

REPEAT PERFORMANCE

You just created the basis of your own advertising campaign, but you are not finished. Your next step is more market research. You identify all the motorcycle manufacturers that

you can, and, using the techniques you read about in the previous chapter, you find out which agencies are handling their advertising. Then you are ready to make up a few packages like the one above in an effort to make the prospects believe that you are the photographer they need to hire. In the end, you may have mailed out ten packages. That is microniche marketing.

The ten individuals who received your mailing will certainly take some notice of your promotion because they are paid to be interested in motorcycles and pictures of them. You have struck a chord close to their hearts, or maybe more of a chord near their cash register. You have their attention; now what do you do? Give each of them a call. Don't worry about bothering them; people in business get phone calls all day long. Introduce yourself as the photographer who sent the photographs of the Maniac motorcycles a week or so ago. If you have to leave a message, identify yourself by a reference to motorcycle photos. You want the prospect to connect your name with photographs of motorcycles, because that is what the prospect buys.

WIDER AUDIENCE

Do not stop at the advertising agencies. You have researched which companies make motorcycles. Each of the companies is likely to have a communications director and/or an executive in charge of advertising and sales. A few sample photographs to these folks won't hurt. The communications director might be looking for someone to shoot for the annual report, and your work might get his attention. The advertising/sales executive could be impressed enough to call the agency's account executive to suggest that the agency look at your work. Nothing will get an ad agency to review your work faster than a call from a client suggesting that they do so.

PROMOTIONAL PUBLICITY

It was probably a publicist who coined the expression, "There is no such thing as bad PR." The appearance of your name in an article in a trade journal or paper can be beneficial. Being mentioned in a photography trade paper might make you the envy of your peers, but it won't do much for you in the eyes of a prospective client because prospects are unlikely to be reading the photo media. But, if the art director or buyer for Rolling Bike motorcycles reads in an advertising journal that you are working on the Maniac account with a competitive agency, it might help you get the opportunity to show your work. Let's say that the Maniac account is a prestigious one. If you get to do the work on its account, you become prestigious. People remember prestigious people.

Press releases should be sent to media outlets whenever:

- You open a studio or relocate your business.
- You are selected to work with a name client.
- You win an award for photography or anything else.
- You expand your services in a significant way.
- You participate in a project or contribute photographs to a good cause.
- You are accepted as a member of a prestigious group.
- You are elected to the board or become an officer of an association.

The media to which you send press releases should be the media that photography buyers, art directors, communications directors, and editors read. It can be national, regional, or local. The important thing is to get your name out wherever, whenever, and however you can.

A strong PR effort can have a direct and/or indirect impact on your business. The direct benefit is when a

prospective client calls you because the prospect read about you in the trade press. An example of an indirect benefit is something that happened to me. For several years running, I sent press releases to a local advertising/communications trade paper. Every new client I got, every campaign I was hired to shoot, every time new work of mine appeared anywhere, the paper received a press release. They received at least two a month from me for two years. About 10 percent of them were published or otherwise reported in the paper because it was local news. Out of those published releases I acquired two new clients. Over the next few years, those two clients purchased thousands of dollars in services from me. Was it worth it? Indeed it was. Writing and submitting a press release is simple and fast work. And when published, these releases reinforce your name in prospects' minds. That leads to prospects calling you instead of you calling them.

In my case, there was also an unusual indirect benefit. As with most local publications, a small team of people produced the trade paper. Over the two years that the releases flowed in regularly, that team became very aware of who I was and what I was doing. When the day came that they decided to do an extensive piece on commercial photography in the local area, guess who they called to interview and photograph in his very busy studio for the article? That's right: I became a very recognizable photographer. Almost every editor, communications director, art director, account executive, and PR agent not only learned my name, but also learned what I looked like. They also learned that based on the trade paper's research, I was one of the busiest photographers in Philadelphia. What was that research? It was the many press releases I had sent. During the same period, they had received only a few similar press releases from other photographers.

Promotional publicity requires a consistent and sustained effort if it is going to work for you. Press releases are used to fill a void when editorial content slacks off. The law of averages says that your releases will get published sometimes if you send them enough times. There are inexpensive computer programs that will help you write good press releases. Once you get the format down the way you want it, you just use it over and over again. The names and dates change, but almost everything else remains the same.

A sample press release has been included below. It contains all the components necessary to be acceptable to media outlets.

Sample Press Release Announcing a Newly Awarded Assignment

(On letterhead)

(Date)

For Immediate Release:

For more information contact:
Pat Photographer
510/555-1234
510/555-9876 FAX
Pat@email.com

Pat Photographer Awarded General Hospital Advertising Photography Contract by ABC Advertising, Inc.

ANYTOWN, USA—(insert Month/Day/Year)

Pat Photographer, one of our region's most prominent professional photographers, announced that she has been awarded the contract to do the

photography work for General Hospital's new advertising campaign, aimed at promoting its extensive services and fine reputation as one of the area's best teaching hospitals. The advertising campaign will be directed by ABC Advertising, Inc., which is the largest advertising agency in the state.

"We have a record of providing top-quality service to our customers. That reputation certainly had a lot to do with our being awarded this contract," said Pat Photographer, the sole proprietor of the business. Pat went on to say that she was excited to be part of this effort to distinguish General Hospital as the best such facility in the region.

Founded in (year), Pat Photography Studio has been serving regional and national advertising clients' needs for more than (number) years.

WORLD WIDE WEB PROMOTION

Today, one of the best promotional tools for photographers is a Web site. Of course, there are so many photography Web sites that yours will likely go unnoticed unless you differentiate it in some manner. So you have to do yours in a way that stands out. Professional design is good if you can afford it. If you can't afford it and you are forced to design your own, first do a little reading on the topic of Web site design and take some time to understand that a good Web site has two interrelated elements: form and function. A Web site with exquisite photography is not going to be studied by a prospect who finds that it takes too long to move from page to page or link to a page. You should also keep in mind that the viewer is not

looking at your site to hire a Web designer. Concentrate on the content of the site—your photographs. Do not get hung up on the design. Clean, neat, and attractive design without lots of bells and whistles is best. The factors that go into the proper design of a Web site are not within the scope of this book, but bookstores have more than ample offerings to choose from.

Inform the Buyer

The average buyer wants to know three things: what your photographs look like, who you are and what kind of experience you have, and the level of your clientele. Therefore, your Web site should have at least three parts: photographic samples, client/publication information, and biographical information. The photographic samples demonstrate the diversity of your work, but you should also have a section or sections devoted to images that are part of your targeted marketing effort. You will read an example of that below. The client section should contain a list of some of your clients, and it should indicate that the information is a partial listing. No one needs to know all of your clients or exactly how many you have. You list the most recognizable names of companies that you have worked for in the past. It doesn't matter if you worked for them three years ago or three weeks ago. As long as your list is factual, it is okay. You do not have to be specific about the exact jobs that you did for a client; the client's name is enough. If you have the rights to display tear sheets of your prior work, and if they are top-notch samples, you should use them. This client portion could also contain copies of those press releases you read about earlier.

The biographical data should provide a brief glimpse into your history in the business. It does not have to be

long. It has to be appealing. Here is a sample of a bio I used on my own Web site, created upon my re-entry into the photography business:

> *Professional photography has been part of my life for nearly forty years. Since beginning my career in 1966, I have been a freelance magazine photographer, commercial portrait studio owner, audiovisual producer, and photography association executive.*
>
> *In 1988 I was appointed to be ASMP's executive director, a post I held through 2002. During that period, photography transitioned from film to digital, and the industry was a hotbed of issues critical to photographers. ASMP represented photographers' interests, and I led that effort. Now I am engaged in photography, writing books and articles about the photography business, consulting on photography business matters, and serving as an expert witness in legal cases that call for my expertise in the field.*

You must have a Web site. The simple fact is that no one is going to think that you are a professional unless you have one. The Web site is the least expensive way that you can get an ever-changing portfolio of your images in front of your prospects. But having a Web site and getting a buyer to visit it are two very different things. Buyers have better things to do than browse the Web looking for talent. The Web is an evaluation tool for them, not a scouting tool. You are going to have to do what every other business with a successful sales-oriented Web site has had to do, that is, you are going to have to drive traffic to your site. There are three ways to drive traffic to your Web site. E-mail, metadata, and direct mail all can be used separately or in combination to drive people to your Web site for a look. Effectively, you can use one promotional tool to lead your prospect to another.

E-mail Promotion

E-mail, which once seemed to be a logical and effective means of promoting your business, is now a hazardous method. The increasing amount of spam being e-mailed to businesses and individuals has become a substantial nuisance. The novelty of e-mail wore off years ago. Today, as an effective high-speed means of worldwide communication, it is a valued tool. When a person's valued tool is turned into a nuisance, the offenders are not well regarded. Unlike postal mail, e-mail arrives in our personal computer. That word "personal" has a territorial connotation, unlike an office mailbox or in-basket. This means that you must be very careful when using e-mail to promote yourself to clients. It does not mean that you cannot use e-mail. It means you must use it intelligently and selectively.

Intelligent use of e-mail boils down to two factors: One, keep your e-mail brief and to the point. Do not add images, logos, HTML, or other elements that will slow down the reception and display on the recipient's screen. Two, make your message immediately understandable. Do not try to disguise the promotional e-mail as anything but what it is—an attempt to get the buyer's attention.

Selective use of e-mail once again goes to the idea of targeting the recipient so that you are not sending the person the equivalent of bulk mail. Put the intended receiver's name, as well as her e-mail address, into the "to recipient" field. An e-mail to <pbuyer@bigads.com> is not as effective as one sent to Pat Buyer <pbuyer@bigads.com>. Promotion is a prelude to sales, and sales work is a personal undertaking. You sell to individuals, not e-mail addresses. You also have to make sure that the e-mail is relevant to the recipient's needs. The medium you choose to communicate with does not alter the buyer's perception of the usefulness of the message that you send. Make sure that your e-mail states why it is relevant. Here's an example:

Dear Pat Buyer:

Your work on Skyways Airline has attracted my attention because of my substantial experience photographing aviation travel, including work for White Cloud Airlines. Please take a moment to visit my Web site (*www.happyshooter.com*). You will find enough examples of my work there to know that you will want to see more.

Thank you for your time,

(Followed by your contact information)

Pat Buyer can read the above e-mail in about thirty seconds. It has a hyperlink in case Pat has the urge to see your work as she reads your e-mail. It has your name and contact information in case Pat wants to get in touch with you, and it associates your name with the subject matter that Pat is working with. It makes it easy for Pat to get to your Web site and does not pretends to be anything more than what it is, that is, a promotion to get Pat's attention. Pat doesn't mind receiving promotional material; it is simply a way to find needed talent. Play it straight with Pat, and Pat will play it straight with you.

PROSPECTING BY REFERRALS

Do you know any other photographers? I'll bet you do. If I sold you a great service or product that you felt you could recommend to other photographers, I'll bet that you would give me the names of a few photographers whom you thought could use what I had to offer. In other words, you would give me a referral. This is an old practice in business. People know others who do what they do, and who need what they need.

A client can identify a new prospect for you in seconds. All you have to do is know when and how to ask for the referral.

I made it a practice to never ask for a referral until I was certain that I had a good relationship with the client. That could take months or even years to build. But once I felt that we had established a business friendship, I was inclined to ask the following question.

"Pat, we've done some fine work together on projects. I think we communicate very well. I want to ask you for something, and I'll understand if you cannot help me. I want to build up my clientele. It's difficult to do because it's getting harder and harder to see potential new clients. [Never call them "prospects" in this scenario.] You must know at least one other editor [or other job title] who could benefit from working with a photographer like me. Can I ask you for the name of anybody you think I might have a good fit with?"

More often than not, I would end up with two or three names to contact. Once given a name or two, I would ask if it was OK to mention her name when I contacted the potential new clients. I can only remember one time that a person said no, and I never called the referrals I received from him. A referral is only good if you cite the credible source who referred you.

My next step was to send the referral a letter telling him that Pat had provided me with his name. The letter promised a phone call in the near future with the hopes that we could set up an appointment. Like all good letters, it was brief and easy to understand.

Dear Lou:

Last week, I met with a mutual acquaintance of ours, Pat Buyer. I have been working with Pat for a year. We have done some impressive work together, including the Maniac Motorcycle ad campaign.

Pat suggested your name as a fellow art director who might appreciate my work and services. She is always so right in my dealings with her that I felt compelled to write to you to introduce myself. If you have some time, I hope you will visit my Web site, *www.happyshooter.com*. I think you'll be pleased. I'll give you a call next week, with the hope that a quick look at the site will make you want to see more of my work.

Thanks for your time,

(Your name)

The letter does not try to disguise itself. It is promotional in nature, and buyers need suppliers, so promotion is OK with them. The value of this promotion is that a person who knows the recipient endorsed it. Credibility is hard to build in business. Borrowing credibility from one relationship to build another is a classic tool in getting new clients.

PROMOTION'S PROPER PLACE

Promotion has to be followed up with good sales work to be effective. Promotion doesn't sell jobs. It only gets you the opportunity to sell jobs. It is the second step in the marketing, promotion, and selling process. Too many photographers expect that a promotional campaign will result in phone calls from people who are ready to buy. That might happen some of the time, but you will never build a business on the number of calls you will receive. Promotion is like the seeds the farmer planted. Before they were planted, the farmer prepared the field; that's market research. Then the seeds were sowed; that's promotion. Then the crop had to be harvested; that's sales.

Promotion is wasted effort and money unless you have done the market research (so you promote yourself to the right people for the right purpose), or if you fail to follow up on that promotion with good sales work. Priming the pump is not the same thing as getting water into the bucket.

SELLING

The fundamental selling process remains the same regardless of whether you are selling your services to an art director, a corporate photography buyer, or a picture editor. In this chapter I have chosen to use the advertising agency as an example because it represents the more common selling experience, and the greater challenge. Agencies are continually interviewing photographers because their needs change with every advertising client they represent. Editorial or corporate photography users usually have a consistent need, so they tend to develop a stable of photographers who meet those needs. Additionally, the fees for the work are not subject to changes from assignment to assignment, as they are in the advertising world. The examples provided are intended to give you an insight into the process and dialogue of selling. As such, they are adaptable to any selling situation, because photography buyers need and want the same things from photographers. The sample dialogues have been developed to demonstrate how you can persuade the buyer that you will be able to fulfill his or her needs and wants.

REVENUES ARE THE GOAL

The sales department is the most important part of any company. There is a simple reason for this. Without sales, there is no work. Without work, there is no billing.

Without billing, there is no revenue. Without revenue, there is no business. You become a photographer to make photographs. You run a business to make money. And that means that you must have a revenue stream. So get this into your head right now: You have to have sales, and that means that you or someone else has to do some selling. Unless you are already good enough to command a rep, and can find one, you will most likely be doing the selling yourself. Many photographers fail in business because they cannot bring themselves to do the sales work required. Nor can they find a rep, because a rep is usually looking for a successful photographer whose existing sales can be increased. Some reps take on startups, but they are usually inexperienced reps who are not proven sales closers. You need to be able to count on your sales department, and that is why you have to learn to do it yourself. Fortunately, approached with the right frame of mind, success in sales is well within the photographer's capabilities.

FOCUS ON YOUR MARKET

Since you have read this far, you know that your sales effort is going to be directed at prospects within certain markets based on your skills and preferences, and on your market research. It is going to be preceded by an effort to promote your name and services to the targets of your sales efforts. Selling is a contact sport. You must make personal contact with a prospect, one on one, to make a sale. And it is a simple task as long as you do not panic. Panic sets in when photographers allow their fear of rejection to take over their business sense. Most photographers want to be known for their photography. It's natural. When a client decides to use another photographer instead of you, it is

often taken as a personal rejection or a rejection of the photographer's work. While this is possible, it is more probable that the decision to use another photographer is based on cost or style, not talent or personality. You can be sure of this if the prospect asks you to bid on a subsequent job. If he didn't like you and/or your work, he would never call you back. If you are never given another chance, you may have a problem with that prospect, or you are really slacking off in terms of your sales effort.

SALES TECHNIQUE

It sure would be nice if prospects received our promotional material and immediately telephoned us to set up an appointment. Maybe it will happen to you every now and then, but if you are counting on getting your business that way, you ought to close up shop now, before your losses get any greater. Right now almost all of your prospects are thinking about the job(s) they are currently working on, not on the next one(s) that they have to do. They start thinking about the next ones after the current job is done or nearly done. That is why they often call you a day or two before the work is needed instead of a week or two before. You will not stop that behavior. It is the way humans work, and if you think about it, that includes you.

PRESENTATION

With consistent effort, you will secure many opportunities to present yourself as a candidate for assignments from prospects. Depending on your locale and the specific client, you may be doing this in one or two steps. Sometimes prospects want to see your portfolio first and then meet with

you when they have a specific assignment to offer. Other times the prospect will do both in a single meeting. There is one time when it is always a two-part process. This is when the client is out of town and you will be handling all discussions via telephone and e-mail. In these cases, you will almost assuredly have proven your photographic capability to the prospect by having sent a portfolio in some form, or by maintaining enough work at your Web site to allow the prospect to make the appropriate judgment. While each situation is different, the process is the same. You have to show the client work that is similar to the work that she needs for the assignment you are being considered for, and you have to have a thorough communication about the assignment with a persuasive slant aimed at making the prospect use you for the job.

Regardless of the method, the presentation of your portfolio should help you persuade the prospect that you are the photographer for the available assignment. To ensure the proper effect, you have to be sure that the images that you will show are related to the kind of work required on the assignment. Again, art directors who want photographs of motorcycles are not very interested in pictures of food, unless it is connected in some way to motorcycles. Magazines that cover snow sports are not interested in tropical island scenes. Corporations doing an annual report are unlikely to be interested in product advertising unless the annual report is going to feature still lifes of products. The display of photographs must send the message that you are a proud professional. Your images, regardless of presentation format or medium, must reflect your insistence on photographic excellence. Saving money or time at the expense of quality in the preparation of presentation images is foolish.

Do not show too few or too many images. Assume that a prospect will look at each photograph for an average of thirty seconds. If you have a thirty-minute appointment, you

want to leave time to speak with the client without rushing. It will take ten minutes for the person to see twenty photographs, which is a good number for a portfolio. Twenty images allows the prospect to see enough, but with the option of stopping. When a prospect stops looking at your samples before the end of the pile, it is because he is convinced that you are either suitable or unsuitable for the job. Until you hear otherwise, always assume that you are suitable. Busy people are usually quite able to tell you that you don't fit the job to be done, and they don't waste time getting to the point and ending the presentation. Some people are very kind and they will continue the presentation even if you do not have a chance of getting the job. If a prospect has stopped short in the portfolio review and he has not expressed an opinion of your work, it is incumbent on you to ask him his opinion. Ask a simple question like, "Well, Pat, I noticed that you didn't take a long look at my work. Does that mean it does or doesn't meet your needs?"

Do not talk while your photographs are being reviewed unless asked to. Photography is a visual art. Let the client's eyes receive the message without interference in the form of voice communications. If you feel that any photograph needs a commentary, then put it on the top of the pile and explain it before the process of review starts. If you have several photographs that require an explanation, you have too many. The review process is about art and technique. It is not about the deeper meanings of the images or educating the viewer about the subject matter.

THE CLIENT'S NEEDS

The prospect's obvious need is for photography. When you got past the portfolio review intact, you qualified as a person who could meet that need. But that qualification only

gets you the opportunity to actually solicit work from the prospect. It doesn't guarantee you any work. To obtain the work you need, you have more to do in the selling process.

The prospect's needs can be broken down into two types: concrete and abstract. The concrete need is for photography, and thus, a supply source. In the simplest terms, you are in the prospect's office to offer yourself as a source of supply. Once you pass the portfolio screening, your next step is to find out what the prospect needs supplied in the immediate future. It is not difficult to do that. The secret to finding out is to ask. I have been amazed at the reluctance of some photographers to ask what work might soon be available. These reluctant photographers seem to feel that it is either beneath them or that it will put the prospect on the spot. Certainly it is not beneath you to ask what work will be available, since you and the prospect know you are there to get some of that work. For the same reason, it is not putting the prospect on the spot. In fact, it is best to get to the heart of the matter without a lot of wasted time. Prospects like direct and open communication. They are busy people and, as such, they do not want to play games. They simply want to get business done as efficiently as possible.

All prospective clients will consistently have a few needs in common. These needs are the abstract features of any service. My experience has been that staying within budget, delivering ahead of or on time, meeting the quality standard, and providing no hassles are universal desires of any prospect. The prospect will rarely mention these intangible needs to you, but they are at work in her subconscious mind all the time. Cost overruns, missed deadlines, and inadequate quality are the hidden worries that all your prospects have. The mere possibility of these things happening causes stress. That is why a no-hassle relationship is important to the client. The worries are enough to bear without worrying that

the supplier is going to have a tantrum during a job. Tantrums increase everyone's stress. Understanding these hidden concerns can help you make sales.

Whether you are a full-time or a part-time professional photographer and regardless of whether you are selling stock or assignment photography, the simple fact is that the marketing duties that you face are the way you get your photographs published. You must either perform the necessary tasks or get an agent to do them for you, or you will not be publishing any of your photographs. If success at publishing your photography is your goal, take the time to learn and to do what you have read in this chapter.

Chapter 9
Multiplying
Your Results

As I mentioned earlier this book, I lived a few miles away from a major horse show venue in Devon, Pennsylvania. The only horses that I had ever photographed were ponies that my kids had ridden. But every time I passed the Devon show grounds, I was reminded that the horse world had to be a fertile market for photography. I decided to penetrate that market. Research told me that Devon had three types of events: horse shows, where the horses are judged much like dogs are judged at Westminster; equestrian riding competitions, where the rider and horse are judged as a team doing difficult maneuvers; and jumping competitions, where the horse's and rider's skills are matched to a course of obstacles.

The next event was a horse show. I bought a ticket and went in with my cameras and lenses, looking quite professional. There were lots of places to roam about and take photographs. The actual scenes of the horses being judged are so boring as to be painful. I photographed horses being groomed, fed, put through their paces in practice. I took

photos of people with horses. Horses with horses, people with people. Whenever someone asked whom I was working for, I'd respond with the truth: no one. I was just trying to learn more about the horse world so I could eventually get paid to photograph such events. The people were amazing. They loved helping me learn all about their world. The most important thing I learned was the names of the six most popularly read and respected horse magazines. These magazines ran horse-related advertising and editorial content. They could be a gold mine, if prospected well. (I also learned what magazines were considered to be sleazy and disreputable, and that was valuable too.)

ASK FOR A REFERRAL

I was networking. I met a lot of people with similar interests with whom I exchanged information. That fits the classic definition of the word "networking." Some of those people were very helpful; one person even knew the editor-in-chief of one of the magazines. I asked her if I could mention the fact that we had met at the Devon Horse Show and that she had been kind enough to give me his name, and she agreed. I made some warm and fuzzy photos of her with her horse and sent them to her a few days later. I also sent one to the editor she knew, along with a letter introducing myself. There were no misrepresentations in the letter; I explained that I was an experienced photographer in many other areas, but not horses, and that I was trying to develop some credentials in the field. I also suggested that he might consider giving me a letter of credentials so I could get a press pass to photograph the Carte Blanche Silver Cup Olympic Jumping Contest, which was about two months away. I sent along some sports photography samples that showed I had a

knack for catching peak action. I then offered to cover the event and give him first refusal right to the images and to the brief story that I would write about the event.

What did he have to lose? Nothing. What did I have to gain? Everything. In short order he called me, and after a brief conversation, he agreed to send the letter for press credentials. We agreed that he would pay no expenses or fees for the work, but would pay standard stock photo and writing fees if he used any of my work products. In the end, he used three inside photos and the five-hundred-word article I wrote. I also sold the magazine the cover photo (see figure 1 on page) of that issue.

EXPAND THE NETWORK

The next step in building the network was to expand it. I asked for ten copies of the magazine. I mailed five of them to the editors of the other five highly respected horse magazines along with letters of introduction proclaiming my availability to do assignments. I also sent copies of the magazine to Carte Blanche's advertising agency and corporate communications director. Both the agency and the communications director licensed some photos from me for other uses. The communications director hired me to shoot the same event for them the following two years.

Then it was time to try to get work from those other magazine editors. I looked up past editions of the magazines and saw what kinds of material they ran. One magazine did a photo feature in each issue. The subjects were a horse, a person, or both. In a different magazine I saw an article on the hard lives of *catch riders*. I learned that catch riders were jockeys who worked the same track, "catching" rides on visiting horse owners' steeds if the horse had no accompanying jockey. I proposed that the feature-using

magazine hire me to do a story on the day-to-day life of a catch rider. I sent its editor action and human interest photos and copies of a few photo stories I had done in the past. I was awarded the job a week later. I spent five days with a jockey, from early morning until the track closed. I photographed him cutting the lawn of his trailer home, sweating off pounds in the sauna to make weight, riding in races, and more. The magazine ran thirty color photos of the jockey with my captions. An assigned writer did the text. It was an impressive photo/text piece.

I mailed copies of the story to the five other editors on my horse magazine list. I got more assignments and requests for stock. One stock request was for a picture of a teenage girl with her horse. It was to be used for the cover of the premiere issue of a new magazine aimed at adolescent horse owners and riders. The cover image would be the heart of the direct-mail promotion used to sell the magazine. I had the very photo they needed. I had taken it on that first day when I was trying to establish the first ties in a network at the Devon Horse Show. Fortunately, I had a release to go with it. My network was producing good revenues, and I wasn't schmoozing art directors at social events for some work.

Figure 10 shows what my horse network looked like at that point.

The diagram shows a revenue-producing network. It portrays what I mean when I use the term "networking." It is nothing more than passing information among individuals with a common interest.

REPEAT THE PROCESS

Revenue producing networks can be developed in a variety of situations. They don't have to start with a referral. Here's another example: I did a great deal of photography

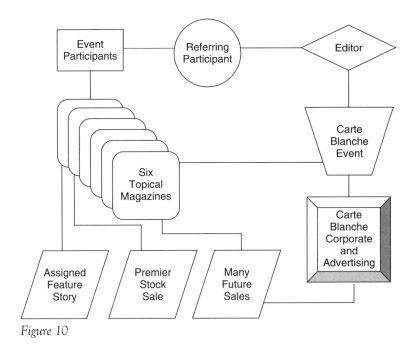

Figure 10

for a major teaching hospital's communications depart-
ment. This institution had one of the first helicopter-
serviced trauma units in the country. Wanting to toot its
own horn, the hospital planned to release a publicity kit
complete with photographs on the first occasion of a hel-
icopter delivery of a trauma patient. I was on the top of
the list of photographers to call because I was half a block
away from the helipad. That positioned me better than
any other photographer doing work for the hospital.
Fortunately, the first day the helipad was used, I was avail-
able. From the time I got the call to the time the patient
was delivered and the helicopter whisked away, only
fifteen minutes elapsed. Once the copter was on the pad,
the whole sequence of events unfolded in a minute. I had
seventeen shots covering the landing, the patient
removal, and the rush to the hospital's door. Over the
next weeks, the best photograph of the series was pub-
lished more than seventy-five times.

Normally that would have been the end of the useful life of the image, but I decided to use it to network for prospects and revenues. I sent the image to the helicopter manufacturer, which bought rights to use it. I sent it to the state police since it was their helicopter, and they bought rights to use it. I then solicited the helicopter's manufacturer for a special assignment to cover emergency helicopters that they had manufactured in action. I was given the assignment. That series of photographs was very complete, as it was an accumulation of many days of shooting in different parts of the country. The images were used in an annual report and a variety of ads and sales brochures.

I also researched magazines to identify possible users of a story to be made from the commercial job. I found several aviation magazines and several medical trade journals. I sold the story I developed to one of each since they did not compete. Using the published story as a sample, I solicited a magazine that published information on military helicopters to give me an assignment to cover the Coast Guard's use of helicopters in rescue operations. I got the assignment. A few months after it was published, I sent copies of it to the communications department of the manufacturer of the helicopters that the Coast Guard was using. This resulted in more licensing sales. I also sent copies to the company that made the hoist and cable that are used to haul people out of the water and into the copter. They also licensed some photos. Figure 11 shows what that network looked like.

That revenue network was developed over about eighteen months' time. It generated about fifteen shooting days and thousands of dollars in licensing fees. It took only simple research and a few letters with sample photographs and copies of previously published photos. It all started with one published photo of a helicopter delivering an accident victim to a hospital's helipad.

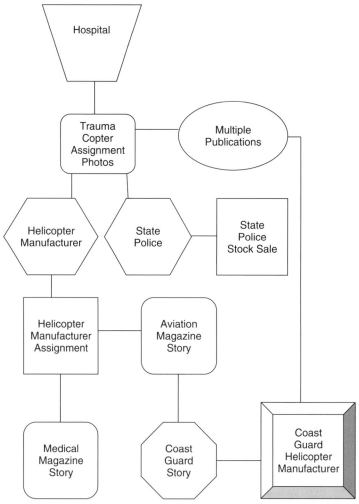

Figure 11

EMPLOY TECHNOLOGY

Using the Internet for e-mail, research, and presenting your portfolio makes the process of expanding your network much easier than it was years ago, when this technology didn't exist. The principle behind it is that there is more than one user for any photograph, and many photographs

have a message that multiple parties can exploit. This common interest is the basis of the network that is developed to produce prospects and revenues.

To reap the rewards of this kind of networking, the photographer has to retain the rights to images that he or she shoots, or at least enough rights to be able to approach multiple markets. If I had sold all rights to the hospital in the above network, I would not have been able to build the network. Retaining rights flexibility is critical to networking images and subject matter. Licensing nonexclusive usage rights is the key to maintaining rights flexibility. The final factor to building a revenue network is working smart. By that I mean seeing the relationship between the three market segments and any single subject. Earlier in the book I advised you not to see yourself as an advertising, editorial, or corporate photographer, but to see yourself as serving all those segments. Now you can see how to turn editorial work into corporate bookings and advertising sales. Today, with a word processor, a Web browser, an image-editing program, and e-mail, you can build revenue-generating networks while sitting at your desk waiting for the phone to ring. Better yet, do it on days when you are not shooting or making sales calls.

As you can readily see, the networking I am writing about is really a combination of promotion and sales work. Those two efforts are carefully linked together within a web of businesses in different market segments but dealing with the same subject matter. It is the softer kind of selling that can be done in the editorial and corporate markets, where your familiarity with the subject matter to be photographed pays off in spades. Unlike advertising clients, corporate and editorial clients are focused on very specific genres of subject matter, and it doesn't change from week to week. Networked promotion and sales are a winning combination

when you can identify the network of prospects that will be interested in the photographs that you can make.

PIGGYBACK ASSIGNMENTS

A piggyback is a ride on someone's shoulders and back. In the publication photography business, it refers to doing additional assignments in a location at which you will be shooting. Piggybacking lends itself to corporate and editorial photography because of the nature of the photographs needed in those markets. It is not a common practice because it takes time to research and arrange such opportunities. But if you can do it, the rewards can be substantial.

An example of piggybacking is three assignments I did for three noncompeting publishers. I was hired to photograph a soccer game for a consumer soccer magazine. The photographs were to be used one time in a single issue of the magazine on a nonexclusive basis. The magazine was particularly interested in coverage of the star player on one team since it was going to run a personality piece in a future issue. Since I had days before the assignment, I researched other publications that might be interested in photographs from the soccer game. One that I found was a magazine that covers sports officials like umpires and referees. I contacted the magazine and suggested a story on soccer referees in field action that would show the refs in dynamic situations as part of the action of the game. The magazine accepted my offer. Then, since one team was from Europe, I contacted the largest newspaper in that country. Normally, that newspaper would have had to rely on a wire service for photographs of that game, assuming that a wire service would cover it. The newspaper assigned me to cover the game for them. The soccer magazine paid me $300 for the game.

The magazine for referees paid me $200, and the newspaper paid me $150. All of them received the kind of photographs they wanted. None of the publications were competitors, so there was no conflict.

THE TOURING ASSIGNMENT

Another way to serve the needs of several clients is to arrange your own photography tour. No, I am not suggesting that you should arrange tours for photographers. I am referring to taking a tour that is planned based on the need of a group of clients. This kind of marketing requires lots of research, but it can be very rewarding.

A photographer friend of mine has done it for years. It is all he does. He spends one month doing research, then one month on the tour, followed by a month split equally between getting the proprietary photographs distributed to clients and getting the nonproprietary photographs set up for his stock agency. Then he starts the process all over again. I'll give you the example he recently gave me of how he does it.

Research the Locale

The first step is a complicated research process. The photographer first selects a region or a country to which he would like to travel. Let's say he elects to go to India. He then researches how customs and immigration officials in that country treat visiting professionals and what warnings about travel to that country might be posted at the U.S. State Department Web site. Once he determines that he can travel to the country without fear of being blown up or arrested for his professional pursuits, he researches the professional photographers' organizations in that country. He will contact them to see if they will put in him in touch

with local professional photographers who might assist him in any number of ways once he is in the country.

Research for Prospects

The next step is to find prospective clients for images from that country. To do that, the photographer uses the Internet to search for U.S., U.K., Canadian, and Australian companies that have operations in India. He limits client companies to those in English-speaking countries to avoid communications problems. Once he finds the companies and the locations in India where they do business, he plans an itinerary that includes several days in each location.

He then prepares a CD of his photographs that most represent the products and services that the prospect companies use. He packages that CD with his itinerary and a proposal offering his services to the prospect companies. He sends that package to the corporate communications director of each company. Then he follows up with phone calls in an attempt to book assignments. He keeps his rates at a very fair level to minimize the prospects' risk. He is going for a medium volume at a medium price rather than a low volume at a high price. His fee is based on a broad usage package that includes the annual report and collateral uses. No advertising rights are included in the package. His fee also includes all expenses since he is approaching the tour as one huge assignment from a multifaceted client base. Breaking down expenses would be very difficult in that situation.

Once he receives enough commitments to make the trip at least break even, he books the travel and begins to arrange for assistance in the country, credentials and a list of photographs desired from the clients, and all the permits, visas, immunizations, etc. that he might need. Then he is on a plane and headed for his destination.

On Location

Before digital photography came of age in the publication photography business, the photographer shot film that he brought with him from the United States and sent that film back to his office, where his assistant sent it out for processing and then edited out any technically inferior shots. With the maturation of digital photography, the photographer uses no film. Instead, he takes his laptop computer with him and uses downtime in hotel rooms to edit his shots. When he arrives back home, he is ready to begin distribution to his clients. If one of his clients needs an image sooner, he either sends it by e-mail or writes it to CD and sends it by any one of many international courier services.

At Home

Once home from his tour, the photographer first fulfills the needs of his clients. Then he begins to repurpose nonpropri-etary photographs for sending to his stock agency. He also looks to see whether he has any groupings of nonproprietary images that might be used by editorial segment prospects.

All of the preceding work is followed by issuing licens-es and invoices for the work delivered. Then, after a short period of rest, the process begins all over again.

My photographer friend has visited more than twenty countries this way. He has an average annual personal income of over $200,000, derived from the assignment fees and subsequent stock sales. All things considered, he is doing very well.

Chapter 10

Developing Good
Business Habits

In addition to creative talent, the successful publication photographer owes his success to three things: understanding of the market, knowledge of business tasks, and good business practices. In the previous chapters, you learned about the market and the most important tasks necessary to get business. Now you need to understand business practices and the tasks that you must perform to employ those practices, that is, how you conduct your business and protect your interests.

This chapter provides a glimpse into the things you need to know operate a successful business.

BUSINESS PLANNING

Business is like a long road trip. You have a starting point and a destination, and you have to plan a route. Once you are on that route, you might find obstacles or incentives that force or compel you to change the route or move faster or slower. Changing the direction or speed is not the same

as changing the destination. Altering the route that you take on a road trip according to changing circumstances is well advised. So is altering your business course as you encounter obstacles and incentives that warrant changes—and you will encounter them. A static business plan is a road map to a dead end. A dynamic business plan is a road map to success. A dynamic plan changes periodically, that is, the planning never really ends; that is why I believe that a plan is useless, but *planning* is indispensable.

STEP-BY-STEP PLANNING

There are six steps in dynamic business planning.

1. Research: Get the information you need.
2. Evaluate: Determine which information to act on.
3. Design: Decide how to carry out the required actions.
4. Implement: Conduct operations to accomplish your plan.
5. Review: Evaluate operational success and make changes as needed.
6. Adjust: Redesign operations to implement the changes needed.

Steps 5 and 6 are repeated periodically until you either reach your destination or determine that the course is not going to get you there and you abandon the plan. Now, let's take a step-by-step look at the planning process.

Research

Research is a critical step in planning. Just imagine that you are traveling from downtown New York City to downtown Los Angeles by automobile. You would certainly review some kind of a road map, determine how many miles you

had to drive, and figure out how much gasoline the drive would take. You would consider how many miles you could drive in a day so that you could determine how many motel rooms you have to check into. You would calculate what the cost of those rooms and daily meals would be. You might consider different roads depending on factors like speed versus enjoyable driving and sightseeing. You would create an itinerary based on your research.

Research is critical to your success in business planning. Market and prospect research are the subjects of subsequent chapters in this book. So you are going to learn the specifics of the research process as you read on.

Evaluate

Evaluating research is just a matter of applying common sense to sets of facts. Let's say that your research indicates that penetrating one market you seek to enter will take a constant flow of promotion over six months, while another market will only take occasional promotion over the same period. Your analysis of your financial condition indicates that you cannot sustain a constant promotional effort without sacrificing other operations. At the same time, you see that you can safely engage in occasional promotion without detriment to your business. This is the process of evaluation, which leads you to select a specific path in your plan— the affordable and accomplishable one.

Design

Designing your course of action is a matter of determining what resources have to be applied and when to apply them to accomplish the tasks necessary to complete the plan. For example, the goal of business planning is to help you make sales that provide the necessary revenues to sustain

the business and you as part of it. In order to make sales, you have to decide on specific markets and then select prospective clients as targets of promotion. You do that by deciding how you want to position yourself in the marketplace. Once that is done, promotional materials can be sent to prospects and the sales effort made to capitalize on the promotion. Different chapters in this book cover those processes.

Implement

Implementation is simply getting the work done. You might call it "acting on tasks" or "getting the to-do list accomplished." It doesn't require an extensive explanation. It is simply acting on tasks to get things done. That being said, it is important to note that many businesses fail because they don't implement successfully. It is easy to have a to-do list. It is quite another thing to accomplish the items on it. Many photographers never find success because they fail to implement one or more parts of their planning. This usually happens because the photographer does not like to do the chores involved and has a mindset against doing them. The most common area this occurs in is the sales effort. Most photographers will tell you that they hate to sell. Those that say this can be broken into two major groups. The first group is comprised of those who have tried selling and really feel uncomfortable with the process. The second group is comprised of those who have never tried it and are so afraid to do it that they never try. Instead, they hope that their promotional efforts will cause clients to make their phone ring, give them work, and make them successful. Well, it never happens that way to a degree that will sustain a business. Failure to implement part of a plan, no matter what the reason, is the kiss of death for the plan and the success that might flow from it. If you are not committed to implementation, don't start. It will save you lots of time and grief, not to mention a bout with depression.

Review

Reviewing is a critical part of the planning process. Business planning is intended to produce results, such as finding prospects and converting them to clients to whom you make sales and from whom you earn revenues. A review might demonstrate that you have secured many prospects and that your promotional activity is on target, but it might also reveal that your sales are not being made to the degree that you projected, so revenues are off. Well, something is out of balance. You cannot continue this level of promotion indefinitely unless the sales are there to pay for it. You have to make changes. Review provides the opportunity to discover the need for and make timely changes in your planning.

Adjust

Adjusting the course and/or cost of action is the final step in the first round of planning. Your review has indicated that your projections are off target. You adjust the plan accordingly and implement the changes. Then, you periodically review and adjust your planning to ensure that it is achieving the results you need to stay in business. If it does not produce satisfactory results, you have to go back to the research and evaluate it again, that is, start over. Intentionally starting over is always better than starting over because of a catastrophic failure.

FINANCIAL PLANNING

You have to make photographs to make money, and you have to make money to make photographs. For professional photographers, the interdependency of photography and business are inescapable unless you have the good fortune

not to need to make money. Most of us are not independently wealthy or being supported by someone else, so we cannot escape the fact that we are in business, like it or not. Ignore the financial aspect of your business and you soon won't have a business.

FINANCIAL MANAGEMENT TOOLS

The primary financial management tools that you will need are a forecast, a profit and loss (P&L) statement, and a balance sheet. A forecast is nothing more than an educated guess about what your P&L will look like once the business up and running. I prefer the word "forecast" to the word "budget" because "budget" is very formal and implies a rigidity that only an established business with a financial history can maintain. A manufacturer of widgets generally knows how many widgets it can sell in a period of time and what the cost of those is likely to be, so it can set up a budget that details all these items. Start-up service businesses and, to a lesser degree, established service businesses, don't manufacture widgets. The scope of their work is less predictable. So, they must estimate revenues and expenses continually. This is planning. Forecasting is dynamic planning. A budget is a plan. Remember what I said about a plan versus planning in the previous chapter. Dynamic businesses require dynamic planning and adjustment.

THE PROFIT AND LOSS STATEMENT

In the paragraphs above, I suggested that when you can not only support yourself, but also have increasing equity, you have achieved a level of success in business. The easiest way to keep track of your equity is through a balance sheet, and

the easiest way to see if you are making a profit is through a profit and loss statement. The P&L will track your profitability, and the balance sheet will track the equity created by that profitability.

The P&L is the most essential tool for financial management. It is a way of keeping score as to whether you are winning or losing in business. It is the manifestation of the one mathematical formula in business that you must understand for financial success: "income minus expense equals profit or loss." Most photographers use a cash method of accounting. For them, the P&L statement simply lists income received from all sources and paid expenses of all types. For those who use the more complicated accrual method, the P&L lists all accounts receivable and payable in addition to income and expenses. Whether using the cash method or the accrual method, the difference is either positive (a profit) or negative (a loss)—hence the name "profit and loss statement." It is a statement that can reflect a loss one month and a profit the next. What is important is that it reflects an aggregate profit over the long run.

THE BALANCE SHEET

The balance sheet is an important tool for two reasons. First, it is how you know whether you are financially successful, and second, it is an important element in the way any prospective lender or investor evaluates your business history and future potential. It is used for those purposes because a balance sheet simply tells the story of how much your business is worth at any given moment in time. If your balance sheet shows increasing equity over a period of time, it indicates that you are running your business successfully. The greater the equity increases, the more financially successful you have been. The balance sheet is a scorecard in the game that we call "business."

Unlike the P&L statement, the balance sheet does not concern itself with revenues and expenses or profit and loss. Instead, it compares assets to liabilities. The difference between the two is your net worth. The P&L statement also indicates the state of your *solvency*. If you own more than you owe, you are in a state of solvency, that is, you own unencumbered assets that are cash or capable of being converted to cash, so you have money. If you owe more than you own, you are in a state of *insolvency*, that is, all your cash and cash value is owed to others, so you really have no money. If you are insolvent long enough, you won't be able to pay your bills. In that case, you might find yourself in a state of *bankruptcy*.

The old adage that bankers only lend money to those who have it is true, and the bankers look at your balance sheet to see if you really have money and how much you have. As with the P&L statement, having a balance sheet tells a lender that you at least understand the fundamentals of financial management. If for no other reason, you should have a balance sheet to impress lenders.

Equity

In its simplest form, the balance sheet lists the assets that you own and compares this total to the total of the debts that you have accumulated. The rest is your business equity, sometimes called *net worth*.

If your business has no equity, you have no business in the truest sense of the word. You are just doing day work for a living. You would be surprised to know how many photographers have no idea what the value of their business is. This lack of knowledge is a primary cause of many photography business failures: Revenues and expenses keep flowing and are tracked, but the difference between debt and assets gets out of hand because it is not watched. Debts piles up faster than assets, and the photographers

find themselves bankrupt, with no reserve capital to weather a bad economic period. They are then forced to find work elsewhere to support themselves. As I said, the balance sheet is the indicator of your level of success in business, or it is the indicator that you are really no longer in business.

Chapter 11

Licensing
and Pricing

The value in your photographs resides in the copyright that protects them from use by others without your permission. Copyright laws put you in exclusive control of your photographs, whether they are taken for personal or commercial purposes. The law says that no one can use any photograph to which you own the copyright unless you permit its use. Copyright is actually a bundle of rights that can be granted by a copyright owner to another person or entity individually, partially, or in total. A copyright can be divided into many component parts. Each of those parts has value. Licensing lets you extract the value from each part.

A license is permission to do something. In fact, in the publishing trade, the words "license" and "permission" are often used interchangeably. Done properly, a license is a legally binding permission. If the terms of a license are violated, the copyright owner can bring a legal claim against the licensor, the party receiving permission. Violation of the terms of a license is a *copyright*

infringement. Infringements must be prosecuted in the federal courts because copyright laws are federal statutes, so state courts have no jurisdiction over copyright infringements.

LICENSING PARAMETERS

A license usually defines parameters of use. Those parameters are normally carved out by circumstances. Circumstances are defined by circumstantial questions, namely, who, what, when, where, why, and how.

Below we will take you through a series of questions you should ask to determine what must be included in your license. Each question is explained so that you will understand what information you are trying to uncover by asking it. Remember that attention to detail is a critically important part of licensing effectively.

Who

Who is the licensee? In some cases, this will be obvious. If a magazine wants to use your image to illustrate an article, it is obvious that the magazine is the licensee. But when a creative agency seeks a license, it is usually acting as an intermediary for the actual advertiser or end user. In other words, Big Noise Advertising, Inc. may be representing Silver Silence Hearing Aids, Inc. To whom should you issue the license—the agency or the principle company that has hired the agency? Normally you would license the principle because it is the end user. In some cases, you might find that an agency wants the license issued to it with an agreement that it can re-license the image to a client. It's OK to do that, but it is best to limit the agency's right to re-license only to the client it specifies.

What

What copyright rights are you licensing? Copyright owners have the right to control the following uses of their works:

1. Reproduction: making copies by any means
2. Derivation: making a new work based on yours
3. Distribution: publication of your work (distribution to the public)
4. Performance: showing your work by mechanical means, as in an audiovisual
5. Public Display: exhibition of your work

These are the basic rights you will be licensing as a photographer. They will be conditioned by other factors, as determined by the remaining circumstantial questions.

When

When will the photograph be used? A license should have a *term*, that is, a beginning and an ending period, after which the rights may not be exercised any longer. For example, suppose you shoot an assignment for a magazine that has an *embargo period*, that is, a period of time you agree to keep the photograph out of use after its initial use. You want to be sure that the magazine's window for the use of the image is clearly stated. Otherwise, if the magazine decides to hold up publication of the image for six months, the embargo starts at that time. That could force your image out of the market for many more months. This is particularly problematic for current-events shooters, whose photographs generally have a life determined by popular interest in the subject matter.

Where

Where will the photograph be used? Now we are talking specifics, like names of magazines, titles of books, company and annual reports, company brochures, and advertising campaign themes. When you include such information in a license, it automatically limits use, and at the same time dispels doubts that can lead to misunderstandings and, at worst, infringements.

Why

Why might you want to include specific limitations? Perhaps you have previously licensed the photograph on a limited but exclusive basis, and you now must prevent it from being used in any way that would violate the preexisting exclusive license. For example, suppose you licensed an image of trout fisherman wading in stream to a manufacturer of fly fishing rods so that it would have the exclusive right to advertise with the photograph in specialty fishing magazines for one year. Then another company wants to use the same image to advertise its sporting travel services in travel magazines. You can do that without violating the exclusivity you previously granted. But you must be sure to restrict the new licensee's use of the image to ensure that no violation occurs, or that if it does, you can prove that you took every effort to protect the exclusive licensee. In such a case, you should specifically restrict the new licensee from using the image in any application for which you have granted an exclusive license that is still in effect. It is not enough to simply spell out the rights that the new licensee has. You must exercise due diligence by stating exactly what rights the licensee doesn't have that might conflict with previously issued licenses.

How

How will the photograph be used? Is it to be used as a promotional illustration, or in a textbook? Maybe it is going to be used in corporate wall art or in a documentary film. Some photographs are licensed for multiple uses, especially those used in promotional applications. For example, a photograph might be featured in magazine advertisements, transit posters, on packaging, and as a point-of-purchase display. Knowing how the image is to be used is important not only to ensure that your license is complete, but also because how the photograph is used is a key factor in determining what you should charge.

Effective licensing makes money for a copyright owner. It makes money from the sale of the immediate license, and it reserves rights that the copyright owner can license later to the original party or other parties. These reserved rights are called *residual rights*. They reside with you and are under your control, so you can grant permission to use them at will. While the immediate licensing of original rights makes money, the licensing of residual rights can make a photograph more profitable.

PRICING

There are four ways to price photography for publication: by the shot, by the day, by project, and by the use. Only stock photography is priced exclusively by the use. Assignment photography can be priced in any one of the ways mentioned, or in some combination of ways. The way an assignment will end up being priced depends on several factors: the market segment, the purchasing policy of the buyer, the routine pricing practice of the trade, and the nature of the publication. Unlike some other businesses, in photography there is no systematic approach to

pricing, except in the stock photography model. Stock photography is priced only by the use of the photograph. Since the photographs have already been produced, the cost of production is not passed on to the user. The price is based on how the photograph will be used. Assignment photography can have several factors that must be considered in pricing: time and materials, rentals and contractors, and intended use of a photograph.

STOCK PHOTOGRAPHY PRICING

How does one determine what the price for a stock photograph's use should be? While that information can be found in books and in computer programs, the best place to find it is online, at stock agency Web sites. Those stock agency Web sites that display pricing information offer the best education about pricing licenses. They are an indicator of what kinds of fees you ought to be getting for licensing stock usage. You want to visit those sites periodically to keep informed about current pricing trends and changes.

STOCK PRICING COMPONENTS

Agency Web sites allow you to select a photograph that you might want to license, and when you ask for the price, you are asked a series of questions. Here are some of the questions that might appear at a typical site.

- How will the image be used?
- What will be the specific application?
- What will be the size of the image relative to the whole page?
- Where will the image be reproduced?

- What will be the print run?
- What will be the circulation?
- What geographic territories will be covered?
- What will be the language of publication?
- What will be the starting date of use?
- What will be the duration of use?

The first few questions will determine what subsequent questions should be asked. The questions for a Web use are different from those for a magazine use. Here is an example of Web usage questions, including answers.

- How will the image be used? Advertising—print/Web
- What will be the specific application? Corporate or promotional Web site
- Where will the image be reproduced? Home page
- What geographic territories will be covered? United States
- What will be the starting date of use? March 22, 20XX
- What will be the duration of use? One month

Based on the answers given, the system returns a licensing fee of $315. If you change the duration of use to six months, the fee changes to $680. If you change by specifying a secondary page location, the fee changes to $220 for one month. Each time you change the answers, the fee quotation changes based on the criteria you entered.

If you price an application like an annual report, the system will ask appropriate questions, adding some to the above list. The system's owner has effectively programmed a checklist into the system to create a semiautomatic pricing system. It is these kinds of systems that make pricing licenses for stock photography relatively easy.

Stock photography licensing systems are not intended to license the unusual or unique photograph. Those systems cannot consider what value-added features might be in a photograph. When you license photography, you can make that determination by understanding the licensee's needs and finding out why it is particularly attracted to your photograph. If your photograph is unique or exclusive, you can get more than the going price. How much more will depend on your negotiating skills.

EXCLUSIVE OR NONEXCLUSIVE

An important point to keep in mind about determining the price of a license to use a stock photograph is whether the licensee wants any exclusive rights. Generally, stock photography licenses are not exclusive in any way. That gives the licensor a greater opportunity to license of the use of an image. But sometimes licensees want some level of exclusivity to ensure that the images they are licensing will not appear in competitive applications. Sometimes licensees will want total exclusivity for a period of time so that the images licensed will appear to be solely theirs and not appear anywhere while they are using them, to avoid confusion on the part of viewers.

There is a simple rule when it comes to licensing any level of exclusive rights. The value and the price go up as the level of exclusivity increases. Later in this chapter we will present a system for determining just how much the price ought to go up.

You must keep in mind that online stock photography pricing systems present prices for nonexclusive use of photographs. Anyone seeking exclusive use has to contact the agency and negotiate a price. You can be sure that the negotiated price for any level of exclusive rights will be higher than the price published on the Internet.

NEGOTIATING STOCK PHOTOGRAPHY FEES

There is only one thing to negotiate when you are licensing stock photographs, and that is the price of the license. There are no expenses or possibilities of a time shift. There is no risk about what the photographs will look like. There are no expenses to negotiate an advance for. Transfers of copyright ownership are not an issue. There is a pricing system in place for arriving at fees. You don't have to do much homework or preparation. Sounds like a dream world, doesn't it? But the fact is that it can be more of a nightmare than a dream. Since the only major variable is price, the competition over sales can be ruthless. As competition holds prices down, many stock photography sellers frequently accept low prices because the cost in time to them for negotiating a few dollars more in revenue is not worth it. Despite the intense competition, there is still an opportunity to negotiate, especially when licensing rights for high-priced uses like advertising.

ABSTRACT FACTORS

When you are negotiating a stock sale, you should try to acquire and consider certain pertinent information. The information you are after is not the statistical kind that you find at a stock agency's Web site. It is more abstract, and it is used to help you sell the client on your image and price. Let's look at each of these types of information.

Type of Client

Who is the buyer? Does the name give you any indication of how deep the buyer's pockets might be or how reliable it might be for payment? You might recognize the name as

an upscale agency that works with prestige accounts, or as a local business with a bad credit reputation. If the buyer is an ad agency or design firm, try to find out who the end user is. If you recognize it as a company that goes first class in the quality of its advertising and promotion, you know that your image must stand out, and that you can probably get a good price for whatever rights the company wants.

Competitive Images

What is the nature of the specific image the buyer wants to license? Is it so unique that the buyer is unlikely to find a similar image among your competitors' collections? Can dozens, hundreds, or even thousands of similar images be found in stock agencies around the world? Can similar images be found in royalty-free collections? If so, you know that you are trading at the lowest end of the price scales. If you are familiar with stock catalogs in print or online, you will have a good idea of how your specific image stacks up in the world of stock photographs. If there are no or few similar images in catalogs, you are in a great position. You must evaluate the extent of the possible competition you will face in making the sale. The level of originality in a stock photograph is directly related to the level of competition it faces and its value in the marketplace.

Timing

When is the client's deadline? Just as in assignment work, a tight deadline is to your advantage. The buyer called you because you have an image that meets a need, but it also must be wanted. Remember, the buyer knows exactly what the image looks like. Coupled with a tight deadline, you can use those temporary assets like an insurance policy. The

message to the buyer is, "Buy now at the offered price and eliminate the risk of not getting the image in time."

Motivation

Why does the company want this specific image? This is not about the need to use it. This is about the image's properties that make the buyer want it. The buyer must like it or he wouldn't price it. Why does he like it? The answer to the question tells you what features to recall when selling your deal to the buyer. In the sales world, there is an old adage: "Sell the sizzle, not the steak." You know why chain restaurants put photographs of their dishes in the menu? They do it for sensory appeal. Once you know what excited the buyer about the specific image, you can casually mention it as your discussion progresses. If you cannot find out why he likes it, then look at it to see what distinguishes it for the type of use he wants to make of it. Then sell that feature.

SELL THE IMAGE

When you are negotiating a stock price, take the time to look at a copy of the image. Ask the buyer what attracted him to it for the intended use. Listen carefully to the answer. Are there aspects of the image that make it uniquely suitable for his use? Are those aspects likely to be found in competitive images? Ask whether he has located other images that meet his needs (not wants). If he says yes, you are ahead of the game. He is calling you because he has not found what he wants yet.

Make him want your image. Talk about how well it fits his intended application. A bit of selling always helps when it comes to getting the best price for your product. Ask if he is looking at the image. If he is, point out one or two special

points about it. If he is not, suggest that he look at those special points now or when he next has the image in front of him. Help him understand just how special your image is.

Not every photograph has special appeal, but learn to look for the signals from the buyer about how much it appeals to him and why. I know from decades of experience that when you have the photograph that the buyer wants, you can get a much higher fee for its use than when it only meets his needs. Wants cost more than needs. Price accordingly.

ASSIGNMENT LICENSING

The way assignments are licensed is practically the opposite of the way stock photography is licensed. As you read above, stock photography licensing is formulaic, logical, and systematic. Assignment licensing is none of those things. Instead, it is an adventure in guesswork and speculation. There simply are no rules, no systems, and no formulas established as industry practice. The reason that assignment licensing is that way is simple. An assignment fee involves more than the cost of the rights to use the image.

The basis of assignment pricing is time, materials, and direct and indirect costs. Skill and creativity separate photographers into classes, with the upper classes being paid more than the lower. But photographers have become aware of the value of the images they produce to the people who use them. And while there is no system for determining that value, it is generally understood that the same factors that influence the pricing of stock photography are at play in the licensing of assignment photography. The more exposure the images produced on assignment will get, the more valuable they should cost.

As that recognition has occurred, photographers have been trying to evolve some means of pegging assignment compensation to use. Many photographers base their fees on the level of use that assignment images will receive. But fees have to be negotiated before the assignment begins, so that level of use is a moving target because clients often expand or contract use after the images have been created. So photographers have a quandary when it comes to pricing assignments because if the usage is not clear, the value of the rights is not clear. To the degree that those things are clear, there is no industry agreement on how to assign that value. The pricing of assignments is evolving to allow photographers to gain some compensation based on the level of use of assignment images, but that evolution is not complete. The photographer has to develop his own system for pricing the value of rights into an assignment fee.

RIGHTS AND MARKET SEGMENTS

In the advertising market, the common demand from buyers is for the copyright or an exclusive grant of all rights. Advertisers want their images exclusively for themselves because they want to protect the perception of their products and services. In the corporate segment, the buyers will most often want copyright or an exclusive grant of all rights to those images that identify the company or its processes. These are usually called *proprietary images*. In the editorial market, the buyer usually wants limited rights. The exceptions would be prestigious magazines that want copyright or an exclusive grant of all rights only for photographs used on the cover of the magazine, since the cover is its flag in the trade; the cover is as precious as a logo is to a corporate buyer, or the product or service identity is to an advertiser.

Corporate photographers will often find complacency on the part of the buyers of their services. This complacency exhibits itself as an interest only in how many days of work are necessary and how much it all costs. The corporate photographer will most often be negotiating to retain useful rights and, for an appropriate fee, negotiating for the level of rights demanded.

Editorial photographers will run into a problem: Buyers will rarely negotiate because they are forced to adhere to day-rate fee schedules set by the publisher, and the only way to increase the fees to be paid is to increase the number of days that the assignment will take. This rarely happens, since most editorial assignments require no more than a few hours to a full day on location. However, when a photographer has unique access or a unique capability it is possible to negotiate higher rates than the publication's standard rates.

ASSIGNMENT PRICING RELATIONSHIPS

Many successful photographers started their careers doing editorial work. It offered more opportunities to get published quickly, and in enough volume to prove to prospective clients that they could reliably make photographs when assigned to do so. The photographs made by editorial photographers are not very different from the kind that corporate photographers make. Once you work for corporations, advertising agencies will start to take notice of your credentials, and you can break into the advertising market. If you shot an annual report for a company, you certainly are good enough to shoot an advertisement for that company or one like it.

That progression has been a path that many photographers have followed for decades. As a result, the fees charged

for assignments in the upper segments of the publication photography business tend to be based on the fees earned in lower segments. Understand that we are talking about the average assignments that the average photographer receives. If you are above average, you can stop reading this book right now and try to get a refund from the bookstore. If you are average or trying to get there, then read on.

Editorial Photography Rates

Editorial assignment photography pricing is based on a *day rate*—a rate per day of shooting. A "day" is considered to be eight hours on location or in the studio. The amount of the day rate will vary depending on the nature of the editorial application and the tier of the publication. A day of work for the *New York Times* might pay $250, while a day for a local newspaper might pay only $75. In the world of magazines, a day for *Time* magazine would pay $500, and a day for a regional magazine might pay $200.

The level of exclusivity needed by a publication will also influence the day rate. Some publications need only nonexclusive usage rights, and others want exclusive rights for a period of time or forever. The day rate will usually be higher as the level of exclusivity increases.

Some publishers also have a *space rate*, that is, a rate that depends on the size at which the image is reproduced in the publication. The more space taken, the higher the fee will be. If, on the basis of the space rate, the total of all space taken by the photographs from an assignment is greater than the day rate, the publisher will pay the space rate rather than the day rate. Most publishers have established their own day and space rates. There is little room for negotiation unless you have special talents or access to the subject that makes it worth the publisher's while to pay you more.

In addition to the fee for the time on the job, publishers also pay for expenses, such as travel, film and processing, digital media and processing time, assistants, etc. The practice of paying for expenses in addition to fees for time and rights is common in all the market segments.

Corporate Photography Rates

Like editorial photography, corporate photography pricing is usually based on a day rate plus expenses. It differs from editorial photography in that there is no space rate. Another difference is that the day rates can vary greatly depending on the work to be done. For example, the photography for a corporate audiovisual show might be $900 per day, while the day rate to shoot its annual report might be $2,000 per day. The more important the application is to the company, the more it will pay for photography.

Most businesses want the exclusive rights to any photographs in which the identity of the company is obvious. Businesses want to protect their image. One way they do it is to buy the rights necessary to ensure that the photographer will not be able to license those images to anyone else. For the most part, photographers will grant that exclusivity because to avoid potential liability, there are few publishers that will ever use a stock image that contains anything that can identify a specific company.

Expenses incurred on corporate photography assignments are also paid as they are in editorial photography. The main difference is that expenses can be much higher in corporate work. An editorial segment client is unlikely to send you on multiday trip involving travel to distant places. A corporate-segment client will often have work to be done that involves travel to other locations. An annual report photographer might find himself working at corporate facilities in several cities or countries. Travel is expensive, and

most photographers will ask for an advance on anticipated expenses so that they do not have to bankroll the client. It is not uncommon for the total expenses in corporate work to exceed the aggregate total of day rates for a specific assignment.

Advertising Photography Rates

The fees for advertising photography vary according to the nature of the specific job and the photographer doing it. There are three popular methods: per shot, per day, and per project. The method used to price a job is usually based on the nature of the assignment; however, each photographer can approach each job as he sees fit.

A per shot fee is the norm for jobs where there will be multiple studio setups over a period of time. Still-life catalog shoots are good example of a job where the per-shot fee is charged. Photographers will normally have a price schedule that is based on the number of elements in addition to the main subject that will appear in a photograph. For example, if the product and one prop appear, the fee might be $100, but if three props are included, the fee might jump to $150. The rationale is that the more elements there are in the photograph, the more difficult it is to light and compose. When you are pricing per job, the expenses for film and processing are usually included in the price. Other expenses are billed to the client.

The day rate is usually applied for location and studio shooting when the assignment calls for working with models, props, settings, etc. and the work requires variations of each shot. For example, if an advertiser wants photographs of two models in a cactus field on a sunny day, wearing the bonnets it manufactures, the job will most likely be priced using a day rate. That job will require photographing the models in a variety of poses from many different angles. It will also most

likely call for shooting at different times of the day to get different lighting angles, in addition to using different backgrounds. There is no way to accurately predict how many photographs will be needed to successfully complete the job. The day rate is the most suitable way to calculate a fee in such a case. All expenses are paid, in addition to the day rate. Some photographers use the term *creative fee* in place of day rate. That is done to eliminate the idea that the photographer is only selling time. Remember, the photographer is selling creativity, experience, and usage in addition to time. Still, the creative fee is time-based, with additional charges.

Project pricing, sometimes called *"turnkey pricing,"* is charging for a job with all time, usage, and expenses included for one set fee. This is the least-used method of pricing because it is somewhat of a gamble. If a project is priced based on three days of work and delays are experienced, extra days are required, or additional expenses are incurred, the photographer could loose money. However, the reverse is also true. If the photographer gets the work accomplished more quickly than anticipated or at a lower expense, then he will profit more than expected.

PRICING ASSISTANCE

Pricing photography offers the greatest challenge to the inexperienced photographer. Fee levels can vary from region to region. The simple fact is that the day rate of a photographer in New York City is likely to be higher than that of a photographer in Tulsa, Oklahoma. The cost of living and doing business varies greatly between those two cities, and prices vary accordingly. The best way to learn about pricing is from established professional photographers in the area where you work. While some photographers will not share or advise, others will. It is always in a photographer's best interest to

have a competitor who knows what the prevailing rates are. If the competitor does not know the prevailing rate, he is very likely to undercharge, and that would drive prices down. When you ask for pricing advice, always make it clear that you are doing so in an effort to have a positive rather than a negative effect on prices.

Pricing properly is critical to your profitability. You must get it right. Financial management starts with a stream of revenues and expenses. Profitability requires that your revenues exceed your expenses, and that makes pricing critical.

USAGE AND VALUE

You can simplify your dealing with usage issues by making a simple value chart. Figure 12 portrays four basic factors influencing the value of rights: limited, unlimited, exclusive, and nonexclusive. The chart in figure 12 portrays the relative value of the categories in a way that will allow you to have a basis for calculating the value of the four major categories of rights when it comes to an assignment.

The rights/value levels in the chart can be put into real-world terms easily. Looking at the editorial magazine marketplace, we can see examples of the principle in action. Magazines like *Time* and *Newsweek* deal in the exclusive categories of rights. For a cover, they insist on

Figure 12

RIGHTS	RESTRICTIONS	VALUE	PRICE FACTOR
Exclusive	Unlimited	Highest	4 × Base
Exclusive	Limited	Upper Middle	3 × Base
Non-Exclusive	Unlimited	Lower Middle	2 × Base
Non-Exclusive	Limited	Lowest	1 × Base

exclusive rights for any purpose and for all time, which is exclusive unlimited. For inside use, they insist on exclusive use for a limited period of time, with additional payment for additional editorial use, which is classified as exclusive rights limited by time and additional use. When purchasing stock photography for the cover, they generally pay three to four times the inside, full-page space rate. That is, if they pay $500 for an inside, full-page photo, they pay between $1,500 and $2,000 for the cover. So we can see that a jump from second place to first place warrants a multiplier of three or four. You can model your system on their value systems. Here's how.

In figure 13 we have added fees to the chart as seen in figure 12. We considered the fact that the lowest editorial assignment fee is about $300 per day, paid by a publication like a trade magazine or a small-circulation consumer magazine for the right to use assignment images one time in one issue with no exclusivity. As we did with stock photography, we used the lowest fee as a base price. We then added multipliers for each rights/value level to increase the fee as the demand from the publishers increase. We arrived at the multipliers by researching the day rates paid by magazines with different levels of rights demands. We found that from top to bottom, there were four tiers that fit nicely within our four levels based on the specific deals that the magazines offer. If you accept our approach, you are on the road to having your own system for determining assignment pricing.

Figure 13

RIGHTS	RESTRICTIONS	VALUE	PRICE FACTOR
Exclusive	Unlimited	Highest	$1200
Exclusive	Limited	Upper Middle	$900
Non-Exclusive	Unlimited	Lower Middle	$600
Non-Exclusive	Limited	Lowest	$300

PRICING RELATIONSHIPS

The average corporate day rate is between two and three times the average editorial day rate. Bottom-level corporate work is paying $600 per day, and top-level work is paying $3,000 per day. Okay, we know that Pepsi and Coke might be paying $5,000 per day, but we are talking about average, not top of the line. So when you want to construct a pricing chart for corporate work, you only have to take the editorial fee chart and increase it by a factor between two and three. In figure 14 we have used a factor of three.

You see that we have created a logical transition from editorial rates to the next-higher segment of corporate rates. Now the challenge is to come up with a system for pricing advertising photography rates.

Advertising photographers run the gamut, from the most creative to average shooters. Top advertising photographers can be involved in assignments that cost as much a half a million dollars. Those jobs are focused on major campaigns by major advertisers. Photographers at that end of the spectrum have their own way of arriving at prices. If you progress to that point in your career, you won't need this book anymore. What we are saying in terms of advertising pricing is directed toward those who are engaged in day-to-day advertising photography for clients who require photographs for local, regional, and limited national advertising. That is the kind of advertising work that most

Figure 14

RIGHTS	RESTRICTIONS	VALUE	PRICE FACTOR
Exclusive	Unlimited	Highest	$3600
Exclusive	Limited	Upper Middle	$2700
Non-Exclusive	Unlimited	Lower Middle	$1800
Non-Exclusive	Limited	Lowest	$900

Figure 15

RIGHTS	RESTRICTIONS	VALUE	PRICE FACTOR
Exclusive	Unlimited	Highest	$7200
Exclusive	Limited	Upper Middle	$4800
Non-Exclusive	Unlimited	Lower Middle	$3600
Non-Exclusive	Limited	Lowest	$1800

advertising photographers engage in. Many photographers in that group calculate their fees on a day-rate basis.

Once again we use the same pricing grid that we used before for editorial and corporate photography assignments. We just change the "1 × Base" number to reflect the higher rates that advertising work justifies. In figure 15 we have taken the corporate base rate of $900 and doubled it. We did that because we know many photographers who do just that to come up with their fee. It seems to accommodate the greater expenses that advertising photographers have, in addition to adding some compensation for the creative levels needed to do the work.

The pricing grid covers the broad range of rights in broad categories. It reflects the reality of a marketplace in which assignments can vary from one-time nonexclusive use of one image to perpetual exclusive use of many images. It is practical and reasonable, and it can even be explained to a client who asks: "How did you come to that price?" Still, it is just a simple matrix that has to have a base number placed into it to work. It is up to you to determine what that base number ought to be. In the high-rent district of New York City, the base number is going to be higher than in the moderate-rent city of Tulsa. The base number has to be competitive with other photographers' fees unless you are far better than they are. If that is the case, you can charge more. In the end, pricing assignment photography is a personal decision based on personal circumstances.

ASSIGNMENT FEE NEGOTIATIONS

Negotiating your fee is always the hardest task in a selling situation. The reason for that is because assignment photographers do not have and have never had an industry-wide pricing method. It is impossible to price creativity by a formula, and your fees include your production and overhead costs, plus your creativity. You can isolate the production costs and know your overhead, but how do you put a price tag on the creativity that you bring to any job? You can't, or at least you can't before the job is done. After it is over, you know, or at least have a good feel for, the level of creative energy that went into the work, but can you really put a price tag on it? I don't think so, and your prospect or client can't put a price on it either. But each of you knows that some jobs require more creativity than others. For example, a studio photograph of a teacup and saucer on a plain white background requires craftsmanship, but how much creativity does it take? It takes some creativity, but not as much as shooting a snowmobile crashing through a snow mound in a winter mountain setting.

The fact is that much work that photographers do requires careful craftsmanship, but it doesn't tax the photographer creatively. While most photographers will try to be more creative than the job calls for, according to the client's specifications, there is often little room to introduce highly creative thinking into an assignment because either time or circumstances do not allow it. This means that you have to distinguish between what I call the "bread-and-butter" jobs and the "champagne" jobs. Most businesses run on bread-and-butter jobs, and they get a real boost in monetary and psychic income from the occasional champagne job. The first thing you have to distinguish before you offer your fee or negotiate it is which kind of job you are being considered for. You will have more serious competition for the

bread-and-butter job, and that means that you have to be more conservative in pricing it.

FEE SETTING

Decide your fee on the basis of the level of experience, capability, and creative talent that the job really requires, and how much better you are than your competition when it comes to the kind of photograph you are being asked to make.

You can point to other assignments of a similar nature, whether done for the same client or a different one, to demonstrate that you received a fee similar to the one quoted for the present job. Show tear sheets of the similar work that was similarly paid. It is your responsibility to justify your fee. Do it with facts and common sense. Quality includes completing the job on time, within the estimated price, and in a creative manner. That is what you are pricing. Anyone can deliver a photograph that meets the prospect's basic needs, but you are going to deliver a photograph that meets the prospect's wants. This is more about selling than about negotiation. It is a good time to be a "broken record." Be direct and confident. Reassert that your fee is reasonable.

ASKING ABOUT THE FEE

If your client cannot accept your fee offer, then try asking a question like, "Based on your experience, what do you think the fee should be?" If the client's answer is close to yours, you can compromise. If it is not, you have a problem, and you have to ask him if he really wants to work with you specifically. You cannot cut your fee by a substantial amount. If you do, you have told the client that you were just trying to exploit him or her with your first offer. The job

cannot be worth $5,000 when you present it and $4,000 the next minute. That is like saying that you padded the estimate by 25 percent. Do you want to work with people who pad their estimates to you?

No matter what people preach to you, there is no such thing as the right fee. If anyone knew the correct fee for photographic assignments, he or she would be indispensable, famous, and wealthy. Fee negotiation requires balancing interests: yours, your client's, and, in the case of an ad agency or design firm, their client. Your fee has to reflect the value of the photograph to the client while preserving the value of what you bring to the job. Value is relative to the experience, creativity, capability, and reliability that you bring to the job, and it is relative to other costs the client will incur during the project. When a company is doing a million-dollar media buy for ads, it is not looking for the cheapest photography around. That would diminish the return on the advertising investment. Keep that in mind. Tell the client that, if he wants to maximize his client's investment, the best way he can do it is by maximizing the quality of the photography. And that means that you are the right person for the job, and that the right person costs more than the wrong person.

Always keep in mind when closing a sale that what you do has value. If it did not, the client would not be trying to buy it. You know the value of your services. The client might not agree with you. If you can develop a good rapport with your client, you might be able to get her to share her insights into the value of a job. That is not easily done, and it usually requires that you have some kind of ongoing relationship with the client. But your value increases as your rapport with the person does. When a person convincingly tells you that she wants you to do the work, but that the fee cannot be more than a given amount, you have achieved some level of rapport. You have convinced the client of your value and gotten the admission that she

cannot afford your price. It is up to you to decide whether to meet her needs. Maybe you can do it by finding a reasonable rationale for lowering your price. Reasons like "I want to show you what I can do" or "Because you are such a good client" are acceptable reasons for lowering a fee, but you should never take a loss. Some differences of opinion cannot be resolved. Sometimes you have to say no. Remember, no one ever went out of business by saying no to a bad deal. Many people have gone out of business by saying yes to bad deals. Stay out of the latter group. Know your value and don't work for less unless you surely know that it is a one-time step to achieving greater value in the future.

USING PAPERWORK

Communicating transactional information to your prospects and clients is one of your prime responsibilities. Estimates, confirmations of orders, and invoices are the primary transactional forms that you will use to do that. Estimates and confirmations might be oral or written, but invoices should always be in writing and clearly state the license that is being granted for the fees and expenses listed on the invoices. All those transactional details ought to be straightforward and contain the terms and conditions that apply to the transaction.

Preprinted forms are an easy way to transact business in writing, but some photographers use letter agreements and others formal contracts. The transactional details of an assignment are best recorded in writing to avoid disputes at a later date, if memories fail their owners. Forms and generic letter agreements can be kept in your computer for use as needed. All you have to do is call up the document and fill in those parts that are specific to the job you are estimating, confirming, or billing.

Examples of form agreements can be found in an excellent book, *Business and Legal Forms for Photographers*, by Tad Crawford, published by Allworth Press. The book is crammed full of any form you might ever need as a professional photographer. I highly recommend it for your library. Personally, I prefer to send letters for all but the smallest jobs and stock photography sales.

THE ESTIMATE

Estimates are used to quote the probable cost of an assignment. An estimate contains a description of the work to be done, the usage allowed, the fee and expenses, and the terms and conditions that govern the transaction.

Whenever possible, you should send an estimate before the work commences. Doing so protects your interest. If the client receives the estimate before the commencement of the work, he has time to review it before the work is done. If the client objects to anything in the estimate, he has time to express that objection before you begin the work. If the estimate reaches the client after the work is done, you will have to deal with the objection from a weaker position, because you have already invested time and materials in the work. You might have even delivered the finished product. You are in the best bargaining position when your estimate is in the client's hands before the work begins.

Estimate Letter

Below is a sample of an estimate that is intended to do two things: impress the prospect and protect the interests of both parties. You will see that it is not a form agreement, as is offered by most trade associations or in other books. The

word processor allows us to customize our documents. You want to make the prospect feel special with personalized service. A form agreement will never do that. The word-processed document does look like it was specially prepared for the prospect. It is simple to make since its main components never change. Only a few details change, according to the details of the job.

(On letterhead)

(Date)

To: Ms. Pat Buyer
Art Director/Buyer
Amiable Advertising
Subject: Slippery Snowmobile Photography
Assignment

Dear Pat:
Thank you for the opportunity to present my estimate for the Slippery Snowmobile job. I am looking forward to finishing this part of our business together quickly so that we can get on to the creative work. If you have any questions, please give me a call.

The assignment requires the creation of three photographs. One is an unmanned snowmobile in a snow-covered outdoor setting. The second is a snowmobile manned by two people and being driven along a tree-lined and snow-covered path. The third is a single-manned snowmobile crashing through a small snowbank with snow flying through the air. Copies of the sketches supplied by you have been attached for reference.

The location for the work is to be in Colorado during the week of January 20 to 25. The deadline for delivery of finished images is no later than January 29.

You require digital files of all images according to the specifications attached.

The usage rights required by the advertiser have been expressed as a "buyout." Understanding that this term can mean different things to different people, I have provided pricing that accommodates different usage scenarios, one of which will certainly meet your client's needs. These options are offered subsequently.

The expenses that will be incurred include:

Assistants & Stylist	$1,750.00
Location scouting	1,200.00
Location permits or fees	600.00
Casting & Models	4,000.00
Travel	2,900.00
Wardrobe	900.00
Film/Processing/Digital services	1,621.00
Total	$12,971.00

Production fees are based on eight days for preparation, travel, shooting, and postproduction work, plus the usage of the photographs.

Option 1: Transfer of full title to copyright, allowing unlimited use for the duration of the copyright, for a fee of $45,000.

Option 2: Exclusive rights for three years, allowing unlimited use for a period of three years from the date of first publication, for a fee of $30,000.

Option 3: Exclusive rights for one year, allowing unlimited use for a period of one year from the date of first publication, for a fee of $15,000. One additional year of usage would increase the fee to $25,000.

The total price of the assignment will be the total of the expenses plus the amount quoted in the option selected from the above list, plus any applicable taxes.

Being fully insured, I am responsible for any liability incurred through my errors, omissions, and/or negligence. Likewise, Amiable Advertising is also responsible for any claims arising from its actions or failures to act.

Should there be weather delays on the assignment, my fee for such days will be $800 for each day plus all expenses incurred, including crew and model expenses. Any additional production days required to complete the assignment will be invoiced at $1,600 per day plus all expenses incurred, including crew and model expenses.

Invoices must be paid within thirty days of the invoice date. Unpaid invoices are rebilled after thirty days, and a $50 rebilling fee applies. Payment is the responsibility of Amiable Advertising as the purchasing party. If Amiable Advertising's policy is to make its payments contingent on payment from Slippery Snowmobiles, then I require a purchase order to me from Slippery Snowmobiles so that I can bill them directly, if need be.

All original film and images produced remain my property. In the unlikely event that the original images from this assignment are lost or damaged by any party after delivery to Amiable Advertising, the full extent of liability shall be the amount of the invoice for the above selected option.

Model releases will be secured from each person in the images. Copies of the model release to be used are attached. If a different model release is required, please notify me and provide a copy of the release with the acceptance of this estimate. A copy of the attached independent contractor agreement will be obtained from all service providers, including models and assistants.

Any alterations, whether additions, subtractions, or otherwise, made to the images after delivery by me are the responsibility of Amiable Advertising and its client. Should a release acquired from a model fail to cover such alterations, it shall be the sole responsibility of the party authorizing such alterations.

Ordering any services to be rendered under this estimate is agreeing to its specifications, terms, and conditions, which become binding to both parties.

Once again, thank you for the opportunity to present this estimate. I will call you in a couple of days to follow up.

Warm Regards,
Happy Shooter

The Estimate's Parts

This estimate letter serves the same purpose as an estimate form, but in a friendlier manner. Remember that prospects would rather buy from a person they like. Most estimates received by buyers have the same worn-out look. Form agreements say, "You were not worth too much of my time." Letters say, "I took the time to create this estimate just for you." Ask yourself, which would you prefer receiving?

The estimate letter contains the four parts previously mentioned: a job description, the price of the major components, usage rights being granted, and some terms and conditions that govern the sale. Let's examine them one by one.

The description of the assignment speaks for itself in enough detail to make clear what the prospect is ordering. By attaching copies of sketches and/or providing thorough verbal descriptions of the photographs to be taken, you are doing two things. First, you are demonstrating to the

client that you have the finished result in mind all the time. This is like saying, "I know what you want, and I am going to deliver it." Second, it protects you from the infrequent but nightmarish scenario in which the client complains that your images are not what he wanted, and he is now forced to use them but is unwilling to pay the full price for the inadequate job. Adding the location and the deadline to the description simply ensures that there are no misunderstandings about either of these two important details.

The usage rights section anticipates the unending contest of rights versus fees. This section asserts that there are defined rights being licensed, and then refers the party to the subsequent options. The usage options are presented in the section on fees. By doing this, the rights become connected to the fee. This has an advantage for you when it comes time to negotiate.

The billable expenses are presented in a summarized fashion. This saves the prospect time because he does not have to sort through line after line of data. If the prospect is the kind of person who wants the details, you can provide the breakdown on request. You could state that in the letter, but my feeling is, why should you offer an invitation to ask for more detail? If you have worked with this prospect before and you know that more details will be requested, you can provide the breakdown of each category in a list accompanying the estimate.

The estimate does not list any markup of expenses. Some photographers add a percentage to the actual cost of expense items. They justify this by claiming that the markup covers their cost of procurement, which is usually for time spent. Many prospects balk at this practice, seeing it as an unjustified fee. I recommend that you include the costs that would otherwise be covered by a markup of expenses in the preproduction fee that you will assess for

the preparations necessary to do the assignment. Prospects do not see preproduction costs as an additional assessment, which is how they see marking up of expenses.

The section presenting the fees has three options regarding rights. You are probably wondering why, since this is not customary in the business. It is more customary to give the prospect an estimate that addresses only the specific rights that the client requested (in this case, a buyout). I'll address the reasoning behind this approach soon. But let's first continue with the explanation of the estimate's structure. The first usage option is the most expensive. In this case, it is the prospect's requested rights. The second option is a less expensive alternative aimed at providing the rights the prospect wants, but for a limited period of time. The third option presents the base-level pricing and usage term, the least expensive alternative. It is the base on which the other two options are constructed.

The base option in the example has been calculated in a very simple, traditional manner. Happy Shooter previously cited his day rate as at least $1,500 a day, but said that it depended on the skill and other factors, like usage, required for the job. This means that he understands that he has more competition on some jobs than on others. Let's face it: There are many photographers who can shoot a snowmobile in a studio up against a cyclorama. Capturing the essence of snow-mobiling is a different story. This is not a simple product shot. It is a product-in-action shot that requires skill, planning, and maybe even physical risk. So Happy is pleased to have the opportunity to charge more than the average fees that photographers in his area charge. In this case, he decides on $3,000 as a basic daily rate. This also includes one year of exclusive and unlimited use.

That means that he calculates his fees on the basis of a production day with that value. Here is the breakdown of his time/fee details in the estimate.

2 preproduc1tion days:	$3,000 (1/2 the shooting rate)
2 travel days:	3,000 (1/2 the shooting rate)
2 shooting days:	6,000
2 postproduction days:	3,000 (1/2 the shooting rate)
Total base fee:	$15,000

In advertising work, clients usually demand exclusivity. They do not want their photographs used by other people. It destroys the impact and the value of the advertisement if its image is seen elsewhere. So Happy's base fee includes one year of exclusive use. Additional years will cost more. Perpetual exclusivity (a copyright transfer) costs the most. Happy must be able to explain this to the prospect in a logical manner. That means that there has to be a rational basis for the increases. So it's a simple matter for Happy. Two years is double the time, so it should be double the cost. Three years is triple. Obviously there has to be a limit, so he sees a copyright transfer as the equivalent of about five years of usage because very few photographs have a marketable life of more than five years. Business decisions have to be based on averages, not exceptions. He might lose on the one in a thousand images that gets used for a decade, but he will make it up on the averages since most advertising images won't be used for more than a year or two, regardless of the level of rights that the client purchases.

THE CONFIRMATION

Once the estimate is received, negotiated, and approved, you should confirm the resulting details to the client. A confirmation form or letter embodying the details of the transaction should be sent to the client prior to the commencement of the work, to have maximum force in any

future dispute. The confirmation process is most important to employ in two situations. One is when an estimate is modified and agreed upon, and the other is when you give an oral estimate at a meeting or over the telephone. The confirmation pins down the terms of the deal you *made* rather the deal you *proposed*.

Whether you use a confirmation form or a letter, it should contain the same level of information that the estimate contained, except the information should reflect the final agreement between you and the buyer. The following example demonstrates what the confirmation letter might look like once the estimate letter above was negotiated and agreed upon.

(On letterhead)

(Date)

To: Ms. Pat Buyer
Art Director/Buyer
Amiable Advertising

Subject: Slippery Snowmobile Photography
Assignment

Dear Pat:
Thank you for the assignment to shoot the images for the Slippery Snowmobile Campaign.
The assignment requires the creation of three photographs. One is an unmanned snowmobile in a snow-covered outdoor setting. The second is a snowmobile manned by two people being driven along a tree-lined and snow-covered path. The third is a single-manned snowmobile crashing through a small snowbank with snow flying through the air. Copies of

the sketches supplied by you have been attached for reference.

The location for the work is to be in Colorado during the week of January 20 to 25. The deadline for delivery of finished images is no later than January 29. You require digital files of all images according to the specifications attached.

The expenses that will be incurred include:

Assistants & Stylist	$ 1,750.00
Location scouting	1,200.00
Location permits or fees	600.00
Casting & Models	4,000.00
Travel	2,900.00
Wardrobe	900.00
Film/Processing/Digital services	1,621.00
Total	$12,971.00

Creative, production, and usage fees are based on eight days for preparation, travel, shooting, and postproduction work, plus the usage of the photographs. The total of these fees for this assignment is $34,971. For this amount, there will be a transfer of the full title to copyright in the images taken as part of the assignment. No rights can or will be transferred to any other party, except that Happy Shooter may use copies of the images and the advertising in which they appear for the promotion of his business interests, in any picture books or photography exhibits, and as art for display purposes. If the images are used for publication of any kind after two years from the date of initial publication in advertisements, Happy Shooter will be paid an additional fee of $5,000 per year. Any applicable taxes will be charged in addition to the agreed-upon fees and expenses.

1. Being fully insured, I am responsible for any liability incurred through my errors, omissions, and/or negligence. Likewise, Amiable Advertising is also responsible for any claims arising from its actions or failures to act.

2. Should there be weather delays on the assignment, my fee for such days will be $800 for each day plus all expenses incurred, including crew and model expenses.

3. Invoices must be paid within thirty days of the invoice date. Unpaid invoices are rebilled after thirty days, and a $50 rebilling fee applies. Payment is the responsibility of Amiable Advertising as the purchasing party. If Amiable Advertising's policy is to make its payments contingent on payment from Slippery Snowmobiles, then I require a purchase order from Slippery Snowmobiles so that I can bill them directly, if need be.

4. All original film and images produced remain my property. In the unlikely event that the original images from this assignment are lost or damaged by any party after delivery to Amiable Advertising, the full extent of liability shall be the amount of the invoice for the above selected option.

5. Model releases will be secured from each person in the images. Copies of the model release to be used are attached. If a different model release is required, please notify me and provide a copy of the release with the acceptance of this estimate. A copy of the attached independent contractor agreement will be obtained from all service providers, including models and assistants.

6. Any alterations, whether additions, subtractions, or otherwise, made to the images after delivery by me are the responsibility of Amiable Advertising and its

client. Should a release acquired from a model fail to cover such alterations, it shall be the sole responsibility of the party authorizing such alterations. This also applies to any violation of the terms of a release.

7. Unless cancelled seven or more days before the assignment, this confirmation constitutes a binding agreement to both parties. In the event of cancellation, any unavoidable expenses incurred by the photographer prior to or after the cancellation will be paid by Amiable Advertising.

 Once again, thank you for the assignment. I look forward to working with you on this assignment and in the future.

Warm regards,
Happy Shooter

THE INVOICE

The invoice is the way you present your request for payment. It should list your terms and conditions, usage license, and fees and expenses. It is best that your invoice restate what your estimate and/or confirmation form or letter contained.

Be certain to know whom the invoice is to be sent to, and how many copies are required. In some companies, invoices have to be sent to the accounts payable department rather than to the person who hired you. It is quite common for photographers to have payments delayed because they sent the invoice to the person who hired them instead of to the proper party. The photographer assumes that the invoice will be passed on to the proper party, and the person who hired the photographer assumes that the invoice is just his

copy and that the photographer sent the original invoice to accounts payable. A simple error like that can cause a payment to be more than a month late.

Unlike estimates and confirmations, invoices are not incorporated into letters. Invoice forms are most common. Be sure that the invoice details the fees and expenses, terms and conditions, and the license to use the photography. I prefer to issue a copyright license and refer to it in and attach it to an invoice. Copyright licenses are discussed below.

STOCK DELIVERY MEMO

If you engage in stock photography by yourself instead of through an agency, you will have to send photographs to prospective prospects for their review unless you have a Web site where the prospects can search for and evaluate the photographs they might have an interest in. Prospects asking for a submission of stock photography to be sent to them will want to see either original or duplicate transparencies or digital images on a CD or DVD. When you ship anything to a prospect, you should send a delivery memo with the submission. The delivery memo should contain details about what the submission contains and the terms under which the recipient may retain it.

At a minimum, a delivery memo will offer a description of the submitted photographs and the total quantity of photographs. It will give permission for the submission to be held for a certain number of days for examination by the prospect and spell out the value of the items submitted in case they are lost or damaged.

Most photography users doing even a moderate volume of business prefer to receive digital submissions because handling transparencies during review not only is a slow

process, but also bears the risk that the original photographs might be damaged. Lawsuits for lost or damaged original film are miserable experiences that buyers want to avoid. Ease of access and avoiding liability is what drives most stock-photography buyers to the Internet to find photographs. Delivery memos are gradually becoming obsolete due to technology, but not everyone is equipped to take advantage of this technology, so the delivery memo still has its place in the business.

COPYRIGHT LICENSES

Some photographers include the agreed-upon terms of a license to use photographs on the invoice sent to the client. I prefer to refer to an accompanying or attached license on my invoice. That way, the license becomes a significant document and the language of the license becomes very clear and unmistakable. Figure 16 shows a copy of a license that I might issue to a client wanting to use a stock or assignment photograph. As you will see, it leaves nothing unsaid, and it clearly relates the license to the photograph to be used.

When a license is about to expire, I also send the client notice of the expiration date, as shown in figure 17. That way, if he wants or needs extended use, he knows a date by which he has to obtain it.

The reminder accomplishes several things. First, it makes it unlikely that the client will use the photograph past the expiration date of the license to avoid being an infringer. Second, it drives reuse sales to me. Third, if the photograph continues to be used beyond the expiration date and this becomes an infringement, I can demonstrate to the client and/or the court, if necessary, how I made extra effort to avoid being infringed upon. Finally, by sending an

Figure 16

Permission To Use Photograph(s)

Sole ownership of the copyright(s) to the photograph(s) licensed for use by this permission rests with Richard Weisgrau. The copyright(s) have been registered with the United Sates Copyright Office. Accordingly, no additional or other permission(s) to use the photograph(s) can be acquired without a written license from Richard Weisgrau only.

Date: March 7, 2006 Permission #: 12587

Permission granted to: Rainy Day Magazine

Attention of: Eddie Editor

1234 Umbrella Street,

Raintown, Oregon

Image number: RW675498

Title: Rain Delay

Provided to client as 30mb Tiff file on CD-Rom in Adobe Color Space

License

Image number RW675498, as shown above, may be used only by Rainy Day Magazine for publication as follows: one time, inside use, in a single issue of Rainy Day Magazine to be distributed within one year of the date of this license. Publication is limited to the English language edition only and not to exceed a circulation of 55,000 copies. Byline must appear adjacent to photograph and must read: Photo by R.Weisgrau/rwpwc.com.

All other rights are reserved. No oral licenses to use this photograph have been or will be granted. The document expresses the full extent of the license granted. This license is not valid in the event of non-payment of the licensing fee stated on invoice # 12587 accompanying this license.

Figure 17

Notice Of Expiring License

PLEASE NOTE: The license depicted below is approaching its expiration date, at which time the use of the image for the licensed purpose must stop. If you have a need to continue the use of the image, you can obtain an extension to or renewal of the original license by contacting Richard Weisgrau. Please be sure to alert all parties responsible for copyright compliance about the approaching expiration date for this license.

Date: March 7, 2006 Permission #: 12587

Permission granted to: Rainy Day Magazine
Attention of: Eddie Editor
1234 Umbrella Street,
Raintown, Oregon

Image number: RW675498

Title: Rain Delay

Provided to client as 30mb Tiff file on CD-Rom in Adobe Color Space

License

Image number RW675498, as shown above, may be used only by Rainy Day Magazine for publication as follows: one time, inside use, in a single issue of Rainy Day Magazine to be distributed within one year of the date of this license. Publication is limited to the English language edition only and not to exceed a circulation of 55,000 copies. Byline must appear adjacent to photograph and must read: Photo by R.Weisgrau/rwpwc.com.

All other rights are reserved. No oral licenses to use this photograph have been or will be granted. The document expresses the full extent of the license granted. This license is not valid in the event of non-payment of the licensing fee stated on invoice # 12587 accompanying this license.

expiration notice to the client, if he infringes and refuses to pay me for the unauthorized use, there is a good possibility that the infringement will be found to be willful. A willful infringement presents the infringer with the greatest financial liability if the photograph was registered with the Copyright Office prior to the infringement, which is something I do all the time.

Chapter 12

Jumping the Hurdles

Publication photography is a highly competitive business. The simple fact is that the supply of photographers exceeds the demand. That fact has stopped very few from entering the business, so the supply/demand rule continues to work to the disadvantage of the photographer. In spite of that condition, many photographers continue to earn a good income from publication. They are separated from the low earners by some combination of three things. They have very good aesthetic ability. They have good technical skills. They know how to do what this book has tried to give you insights into doing. But there is more to learn yet.

ADVISORS AND CONSULTANTS

Good and bad advice are easy to come by and hard to distinguish. Understanding the nature of the business is imperative to operating successfully within it. If you are

currently engaged in publication photography or about to become engaged, you are or will be offered lots of advice from many different sources about how to conduct your business. With forty plus years of experience in the business, I have this recommendation to make. When it comes to accepting advice, you ought to follow the same rule that journalists are supposed to follow when a source provides them with information: Confirm the information by another source or other means. Don't act on the information until you have good reason believe it to be correct. Remember the old adage, "If it sounds too good to be true, it probably isn't true."

During my fifteen years as the executive director of ASMP, many photographers came to ASMP for advice on how to reverse a situation that resulted from advice they had received from other photographers who had more experience, from lawyers who know nothing about the photography business or related laws, and from consultants who advised them even though they had never been in the photography business. The fact is that photographers crave advice to advance their careers. In that respect, they are no different from other professionals. But publication photography is a niche business, so advisors who only have general business experience are often unqualified to give advise. Also, some advice-dispensing photographers do not have the credentials to give the advice they offer. If you get your advice from a person who has no record of long-term success, you might be getting advice from the next person who is going to fail in the business.

When it comes to legal issues that might crop up in your publication photography business, seek a competent attorney with experience in the specific area of law that is involved. On more than one occasion, I have watched a photographer with a copyright infringement claim that could have been worth thousands of dollars end up with

practically nothing because he decided to save money by using the legal services of a lawyer relative who was engaged in the general practice of law. If you are a sports photographer, prospects are very unlikely to hire you to shoot food. Prospects understand the meaning of the word "qualified," and you should too. Special work requires specialists.

WORKING WITH YOUR CLIENTS

The clients of a publication photographer may include one-man businesses, medium-sized advertising agencies, or giant corporations. Regardless of the size of the entities, there is one common element—you are dealing with people, not companies. Those people have titles like editor, photo editor, art director, art buyer, communications director, public relations director, and, in the case of small companies, owner. Always remember that you are developing a personal relationship when you court a prospective or existing client. For the most part, the publication photographer is dealing with a representative of a company and not its owners and policy makers.

The larger the company, the more inflexible it will be in a negotiation. That is because the company has to control the actions of its employees to the extent that it can, so it sets limits and guidelines that they must adhere to. When you run into a client policy that you do not like, don't take it personally. The person delivering the unwanted message is only the messenger, and ought not be punished for delivering what he is ordered to deliver.

When you are presented with a prospective client's terms or conditions that you cannot accept, all you have to do is say no and explain why you must refuse. Never get angry. If enough good photographers say no, the terms will change, and the company will better its offer and hire

a photographer. You can be certain that the person in the company that you got angry with is going to give the work to someone who did not get angry. Anger begets anger, and mutual anger often ends relationships.

PRICE AND VALUE

You set the price for your photography. Your client also sets the value of your photography. If you set a price that is higher than the value assigned by the client, you have to accept, negotiate, or reject your client's position. Sometimes clients won't budge. Here's why.

Advertising Segment Limitations

In the advertising business, the agencies are awarded jobs from advertisers based on a bid they have made to do the work involved. That bid is made long before the photographer is hired to work on the account. The agency allocated a certain amount for photography in its bid. To exceed that amount, the agency has to do one of three things. It can lose money, or it can cut back expenses on another part of the work to be done. Neither is palatable because no one wants to take a loss, and cutting back on another aspect of the work means compromising quality, which is taboo in the creative communications business. The third option is to go back to the advertiser and ask for more money. Now put yourself in the agency's position. Would you want to explain to your client how you managed to underestimate the cost of the work and now need more money? I doubt it.

Certainly the agency has some leeway to negotiate, but it is not boundless. If you are asking for a lot more than the agency estimated, it is going to tell you that as far as it is

concerned, the job is worth a certain dollar amount to it and not more. You will have to decide whether you can do the work for that amount. If you cannot, you should bow out gracefully, not angrily, keeping the door open to be eligible for the next job.

Corporate Segment Limitations

In the noncreative business sector, the value of photography is usually underappreciated. Businesspersons have one goal—a profitable bottom line. That drives them to sacrifice creativity for the sake of profits whenever the creativity is not going to drive significant dollars to their doorstep. Businesspersons often use the phrase "Show the flag." It means, keep the company in view so no one forgets about it. It is a routine part of the cost of doing business, and you cannot trace any part of the profits to it. On the other hand, there are times when a company has a need for photography that can help drive dollars in the door as a direct result of publication. An annual report is the best example of a dollar-driving publication.

The corporate client's staff person whom you will be talking to is in the same position as the advertising agency that was explained above. There is a budget for a publication project. Photography is part of that budget. No one in a company wants to go and ask for more money because he underestimated. Just as in the case of advertising, you will have to decide whether you can do the work for that amount, and bow out gracefully if you cannot.

Editorial Segment Limitations

Editors report to managing editors. Managing editors control the budget of the editors. A monthly magazine allocates a certain dollar amount for the photography that will appear

in the publication during the budget year. Each issue has a certain level of funds allocated to it. The number of pages of the magazine will depend on the ad sales. The editor knows that a certain percentage of the publication's pages will be occupied by photography, so a certain percentage of ad sales can be used to pay for photography. Book publishers have a budget for a book. Only so much of that book's costs are allocated for photography. The person buying photography is not going to spend more than that amount. Once again, the client is setting the value, and you have to try to negotiate the client's assigned value to come close to your assigned price. Everyone has some leeway, but how much is the question. You have to test that, and then decide whether you want the work or not.

Merchandise Segment Limitations

Greeting cards, posters, calendars, and similar products are priced by their publishers through a formula. Consequently, the prices they pay for photography and other components are precalculated into the formula. They usually have a fixed fee or percentage of royalty that they pay for photography. They are in the mass-production business, and they do not customize deals with photographers. You can generally expect to be offered a payment on a take-it-or-leave-it basis. Your decision is whether to take it or leave it.

DEVELOPING A MINDSET

Being a publication photographer is easy. All you need is a camera and lenses and a business card. Finding a few people who will publish your photography is easy. There are numerous photography users who buy photography at every quality and price level.

Being a successful publication photographer is not easy—not if you define success as making enough money to live a middle-class lifestyle. Success in publication photography requires aesthetic talent and technical skill. But most who have aspired to become successful publication photographers have those qualities, and yet many have failed. You can be the da Vinci of photography—an artistic and technical genius—and still fail because success in business requires business acumen, and no one is born with that. It has to be developed.

Your acumen for business is developed by learning and doing on a continuing basis. The better you get at business, the more money you can make. The progression that professional photographers follow is from photographer to photographer-businessperson to businessperson-photographer, and some eventually become just businesspersons and hire others to do the photography. One thing I can tell you with certainty after more than four decades in the business is that unless you at least get to the photographer-businessperson stage, you will fail economically. That will make you an amateur photographer.

If you can get to the businessperson-photographer stage, you are almost assured of success in the long term. Most successful photographers with more than five years in the business have learned that business comes first, and the photography only gets done profitably if the business is done right. But don't be alarmed. Most of the group are highly creative photographers who have learned to change hats as their role has changed in the course of doing business. It is a learned behavior, not an innate one.

You have now completed reading this book. What you do with the information and advice it provided is up to you, but one thing I am sure of. If you have learned what this book has offered, and if you read the books listed in the following chapter, you will learn all you need to know about the business aspect of publication photography. Then, if you

use Internet-based resources to find continuing sources of education from the trade associations, and use marketing and information sources to build your business, you will succeed, provided that you apply your knowledge with discipline and determination.

I have often heard that presentation is 80 percent of getting an assignment. I think that is true. But what is also true is that marketing is eighty percent of the effort to get the opportunity to make the presentation, and that planning is 80 percent of good marketing. So here's my final advice. Make a 100 percent effort. Even if you are only 80 percent effective, you will do just fine. Giving 100 percent is a matter of will. Developing the mindset to exercise that will is done by simply refusing to give less than 100 percent in your effort to publish photography. Can you do it? I'll bet you can.

Chapter 13

Resources

As you read this book, you came to understand that there is a great deal of information you need to be successful at publishing your photography. Publication photography is a business and, whether your business is part- or full time, continuing education is needed to learn what you do not know and to keep abreast of changes in what you do know. This book has touched upon many important aspects of the business, but it cannot provide all the information you need on an ongoing basis to run a successful business. This chapter provides you with references to a variety of sources and books through which you can increase your knowledge and, as a result, increase your chances of long-term success.

PHOTOGRAPHERS' TRADE ASSOCIATIONS

Advertising Photographers of America (APA)

Web site: *www.apanational.org*
APA is an excellent organization for advertising photographers. It has six regional chapters in the United States. They

are located in Atlanta, Chicago, Los Angeles, New York, San Diego, and San Francisco. APA's goals are to:

- *Establish, endorse, and promote professional practices, standards, and ethics in the photographic and advertising community.*
- *Mentor, motivate, educate, and inspire in the pursuit of excellence.*
- *Champion and speak as one common voice for advertising photographers and image makers to the advertising industry in the United States and the world.*

American Society of Media Photographers (ASMP)

Web site: *www.asmp.org*
ASMP is the oldest and largest association of publication photographers in the world. It has forty regional chapters in the United States. The ASMP chapters are: Alaska, Phoenix, Tucson, Atlanta, Austin/San Antonio, Baltimore, Central Florida, Chicago, Colorado, Connecticut, Dallas, Hawaii, Houston, Kansas City, Long Island, Los Angeles, Michigan, Minneapolis/St. Paul, New England, New Jersey, New Mexico, New Orleans, New York, North Carolina, Northern California, Ohio Valley, Ohio North Coast, Oregon, Philadelphia, Pittsburgh, San Diego, Seattle, South Carolina, South Florida, St. Louis, Tennessee, Utah, Washington, D.C., and Western New York. The purposes of ASMP are to:

- *Protect and promote the interests of publication photographers publication.*
- *Promote high professional standards and ethics.*
- *Cultivate friendship and mutual understanding among photographers.*

Editorial Photographers (EP)

Web site: *www.editorialphoto.com*
EP is an excellent organization for editorial photographers. It does not have chapters, but it stages regional seminars in the United States. Its purpose it to *advocate for fair contracts from publishers and promote the position that both photographers and publishers must maintain a healthy symbiotic relationship in which both sides can prosper and profit.*

National Press Photographers Association

Web site: *www.nppa.org*
NPPA serves the interests of both still and video press photographers. It does not have chapters, but it does stage regional seminars. The purposes of NPPA are to:

- *Advance photojournalism in all its forms.*
- *Create, promote, and maintain a high spirit of fraternalism and a high standard of conduct among its members.*
- *Oppose violations and infringements of the rights of photojournalists or their organizations.*
- *Promote a better understanding of photojournalists' problems.*
- *Support legislation favorable to and oppose legislation unfavorable or prejudicial to photojournalists.*
- *Work to maintain freedom of the press, in all its forms, and to execute the constitutional rights of journalists.*
- *Cooperate with all recognized local photojournalism associations consistent with the aims and objectives of NPPA.*
- *Provide educational opportunities for those involved in photojournalism.*

Professional Photographers of America (PPA)

Web site: *www.ppa.com*
PPA is the oldest and largest photographers' association. It serves photographers in both the general consumer market and the publication market. It has affiliated organizations worldwide and in many states in the United States. You can download the seven-page affiliate directory from the PPA Web site. PPA's purposes are *to increase its members' business savvy as well as broaden their creative scope. It aims to advance their careers by providing them with all the tools for success.*

Stock Artists Alliance (SAA)

Web site: *www.stockartistsalliance.org*
SAA is an organization of photographers who produce stock photography. It does not have chapters, but its membership is worldwide. Its purpose is *to protect and promote the business interests of its members with regard to the worldwide distribution of their intellectual property.*

International Association of Panoramic Photographers (IAPP)

Web site: *www.panoramicassociation.org*
IAPP is an organization of photographers who produce panoramic images. It does not have chapters. Its purpose is *to create a membership network to educate, promote, and exchange artistic and technical ideas and to expand public awareness regarding panoramic photography.*

USEFUL WEB SITES

Each of the following Web sites has good information to offer the publication photographer about some aspect of the

business. At the time of this writing, all these Web sites were active and useful. However, like the actual world, the World Wide Web is continually changing, so it is possible that by the time you read this book, some of these references will no longer be active. In that case, you should remember that you can find sites like these by simply doing Internet searches and taking the time to cull the results to find the good information that is available to you on the Internet.

Marketing Research Asset Web sites

The URLs provided below lead to a variety of Internet databases that will be of help in trying to identify prospects who might publish your photography. Since Web sites are often redesigned, it is possible that some extended URLs will be inaccurate when you try them. In that case, shorten the URL to end after .com or .org and try again to get to the Web site's home page. Once there, you can find your way to the specific pages that contain the useful information.

- *www.mediafinder.com*—Data on 70,000 U.S. and Canadian periodicals
- *www.ulrichsweb.com*—Data on 250,000 worldwide publications
- *www.redbooks.com/Nonsub/aboutus.asp*—Data on 14,000 advertising firms and 18,000 advertisers
- *www.indiandata.com/trade_books.html*—Data on hundreds of trade-book publishers
- *www.businessfinance.com/trade-associations.htm*—Lists of trade associations by the types of businesses they represent
- *http://dir.yahoo.com/Business_and_Economy/ Business_to_Business/News_and_Media/Magazines/ Publishers*—Directory that will lead you to lists of publishers, advertising agencies, and more

- *www.journalismnet.com/papers*—Directory of hundreds of newspapers worldwide

Buyers' Trade Associations

- American Association of
 Advertising Agencies *www.aaaa.org*
- Outdoor Advertising
 Association of America *www.oaaa.org*
- National School Public
 Relations Association *www.nspra.org*
- Public Relations Society
 of America *www.prsa.org*
- American Institute of
 Graphic Arts *www.aiga.org*
- Graphic Artists Guild *www.gag.org*
- Magazine Publishers
 of America *www.magazine.org*
- American Society of *www.magazine.org/*
 Magazine Editors *Editorial*
- American Association of
 Sunday and Feature Editors *www.aasfe.org*
- American Agricultural
 Editors Association *www.ageditors.com*
- American Society of
 Business Publication Editors *www.asbpe.org*
- American Society of
 Newspaper Editors *www.asne.org*

Calendar, Greeting Card, and Poster Publishers' Web Sites

The below list of URLs will lead you to the Web sites of companies that publish calendars, greeting cards, and posters. Some of the companies publish all three, while others publish

only one or two applications. I selected these on a simple basis. I had five minutes to spare while in a large chain bookstore. I looked at the selection of calendars on display for sale. The list below was the result of those five minutes. If I had had ten minutes, the list would have been longer.

- *www.avalanchepub.com*
- *www.willowcreekpress.com*
- *www.graphiquedefrance.com*
- *www.fireflybooks.com*
- *www.zebrapublishing.com*
- *www.agdateworks.com*
- *www.wendtworldwide.com*

Stock Photography Agency Web sites

The four URLs below lead to the Web sites of top stock photography agency Web sites. These sites offer online search and pricing of stock images. If you are selling your own stock, you will want to register at one of these sites for pricing help.

- *www.gettyimages.com*
- *www.corbis.com*
- *www.indexstock.com*
- *www.masterfile.com*

Business and Legal Informational Web Sites

The following Web sites provide useful information for publication photographers.

- *www.useplus.com/glossary.asp*—An online glossary of licensing terms useful when licensing your photographs for publication

- *www.pdnonline.com*—The online version of *Photo District News*, which is the best trade publication for the publication photographer
- *www.copyright.gov*—The Unites States Copyright Office, where you can get circulars that explain copyright and copyright registration, in addition to the forms used to register copyrights to your photographs
- *www.photographersindex.com/stockprice.htm*—An online stock photography fee calculator
- *www.editorialphoto.com/resources/estimator*—An online program that helps you arrive at prices for your photography
- *www.creativepro.com/category/home/158.html*—News of important developments in the stock photography business

Photography Hosting Sites

PBase	*www.pbase.com*
.mac	*www.apple.com/dotmac*
Hosting Photography	*www.hostingphotography.com*
Photo Navy	*www.pnavy.com*

INFORMATIVE TRADE BOOKS

No one book can provide all the insights you need to be a successful publication photographer. If one book could do that, you would be wise to read other books, because different authors are going to provide different points of view and tips based on their unique experiences, and they will explain what they know in their own distinctive way. The list below contains some books that I have either written or read, and which I believe you will profit from

reading. The books were written by bona fide experts in their fields. That cannot be said about all trade books.

Allworth Press, the publisher of this book, published all the titles below. Why no other publishers' books? The answer is simple: Allworth takes pains to verify the credentials of the authors of the books it publishes so that you will get authoritative information. That is not an advertisement for Allworth. It is just a fact, and that fact led me to select Allworth as the publisher of my four books.

- *Pricing Photography, by Michal Heron and David MacTavish (2002)*: This book provides photographers with information on estimating prices, identifying pricing factors, negotiating fair deals, and more. It contains over fifty pages of pricing charts to help photographers in pricing their work.
- *Business and Legal Forms for Photographers, Third Edition*, by Tad Crawford (2002): The book contains forms and checklists for any situation a professional photographer might encounter, including contracts for assignment photography, model releases, assignment estimates, confirmations, invoices, delivery memos, licenses for Web usage, nondisclosure agreements, and more.
- *The Photographer's Guide to Marketing and Self-Promotion, Third Edition*, by Maria Piscopo (2001): This book tells how to find clients and make money. It explains how to build a marketing plan that incorporates self-promotion, advertising, direct marketing, public relations, and the Internet. Promotion pieces, portfolios, researching and winning clients, negotiating rates, and the ethics of good business are just a few of the topics covered.
- *The Photographer's Guide to Negotiating*, by Richard Weisgrau (2005): The book examines the

nature of negotiating and the traits of a good negotiator, the best strategies and tactics for business dealings, ways to plan for a negotiation, and how to negotiate assignment deals, stock photography sales, contracts, purchases, and more.

- *The Real Business of Photography*, **by Richard Weisgrau (2004)**: This covers all the essentials of running a photography business: setting a strategic vision and managing finances, networking for prospects and retaining clients, market research, a client-specific marketing approach, and a self-reliant business spirit. Difficult business scenarios are played out as dialogues between a photographer and an art director.

- *Licensing Photography*, **by Richard Weisgrau and Victor Perlman, Esq. (2006)**: The book explains with step-by-step instruction how a photographer should craft licensing agreements, price licenses, and negotiate fees. It contains sample licenses, agreements, and legal advice in layman's terms, including a primer on copyright that explains what a photographer's rights are under the law.

- *ASMP Professional Business Practices in Photography*, **by American Society of Media Photographers (2001)**: This book, compiled by ASMP from the writing of over two dozen industry experts, provides expert information about key business practices and industry standards in both stock and assignment publication photography. It provides answers to legal and business question that professional photographers encounter, including topics such as estimating prices, form agreements, electronic technology, and much more. It also contains dozens of ready-to-copy legal and business forms, checklists, and an extensive cross-media bibliography.

Index

 Books from Allworth Press

Allworth Press is an imprint of Allworth Communications, Inc. Selected titles are listed below.

The Photographer's Guide to Negotiating
by *Richard Weisgrau* (paperback, 6 × 9, 208 pages, $19.95)

The Real Business of Photography
by *Richard Weisgrau* (paperback, 6 × 9, 256 pages, $19.95)

Licensing Photography
by *Richard Weisgrau and Victor C. Perlman* (paperback, 6 × 9, 208 pages, $19.95)

How to Grow as a Photographer: Reinventing Your Career
by *Tony Luna* (paperback, 6 × 9, 224 pages, $19.95)

Photography Your Way: A Career Guide to Satisfaction and Success Second Edition
by *Chuck DeLaney* (paperback, 6 × 9, 304 pages, $22.95)

Starting Your Career as a Freelance Photographer
by *Tad Crawford* (paperback, 6 × 9, 256 pages, $19.95)

The Photographer's Guide to Marketing and Self-Promotion, Third Edition
by *Maria Piscopo* (paperback, 6 3/4 × 9 7/8, 208 pages. $19.95)

Profitable Photography in the Digital Age: Strategies for Success
by *Dan Heller* (paperback, 6 × 9, 256 pages, $19.95)

ASMP Professional Business Practices in Photography, Sixth Edition
by *American Society of Media Photographers* (paperback, 6 3/4 × 9 7/8, 432 pages, $29.95)

Photography: Focus on Profit
by *Tom Zimberoff* (paperback, with CD-ROM, 8 × 10, 432 pages, $35.00)

Business and Legal Forms for Photographers, Third Edition
by *Tad Crawford* (paperback, with CD-ROM, 8 1/2 × 11, 192 pages, $29.95)

Pricing Photography: The Complete Guide to Assignment and Stock Prices, Third Edition
by *Michal Heron and David MacTavish* (paperback, 11 × 8, 160 pages, $24.95)

Please write to request our free catalog. To order by credit card, call 1-800-491-2808 or send a check or money order to Allworth Press, 10 East 23rd Street, Suite 510, New York, NY 10010. Include $6 for shipping and handling for the first book ordered and $1 for each additional book. Eleven dollars plus $1 for each additional book if ordering from Canada. New York State residents must add sales tax.

To see our complete catalog on the World Wide Web, or to order online, you can find us at **www.allworth.com**.